IMAGES
of America

CAPE MAY

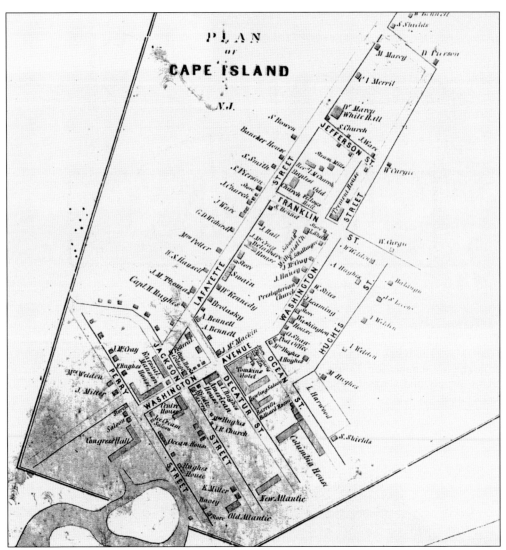

In 1850, cartographer Joseph Nunan drew a map of southern Cape May County, showing buildings, owners, and roads as they existed then. Cape May City, identified here as Cape Island, has seven well-developed streets that today form the heart of the now much-larger resort. The hotels are concentrated on four deep oceanfront blocks between Perry and Ocean Streets. (Cape May County Historical and Genealogical Society.)

On the Cover: These two unidentified young ladies visit Cape May in the opening decades of the 20th century. They were probably staying at one of the seaside resort's many hotels, boardinghouses, or private cottages. At the time, two rail lines brought visitors into the city, and side-wheeler steamboats from Philadelphia made daily stops in the summer months. (Cape May County Historical and Genealogical Society.)

IMAGES
of America

CAPE MAY

Joseph E. Salvatore, MD,
and Joan Berkey

ARCADIA
PUBLISHING

Published by Arcadia Publishing
Charleston, South Carolina

Printed in the United States of America

Library of Congress Control Number: 2014943798

For all general information, please contact Arcadia Publishing:
Telephone 843-853-2070
Fax 843-853-0044
E-mail sales@arcadiapublishing.com
For customer service and orders:
Toll-Free 1-888-313-2665

Visit us on the Internet at www.arcadiapublishing.com

*Dedicated to the visionaries who transformed a sleepy,
post–World War II city into a vibrant tourist destination
rich in architectural and cultural history*

CONTENTS

ACKNOWLEDGMENTS

The authors wish to thank the Cape May County Historical and Genealogy Society, the Center for Community Arts, the Mid-Atlantic Center for the Arts and Humanities, Don Pocher, Pip Campbell, and H. Gerald MacDonald. All of these people and organizations have contributed knowledge, resources, and support for this book. Also deserving of a big thank-you is our Arcadia editor, Katie McAlpin Owens, whose expertise guided us effortlessly through the publishing process. Unless otherwise noted, images in this volume appear courtesy of the Naval Air Station Wildwood Aviation Museum (NASW), the Cape May County Historical and Genealogical Society (CMCHGS), the Center for Community Arts (CCA), H. Gerald MacDonald (HGM), Don Pocher (DP), and the Library of Congress (LOC).

INTRODUCTION

Cape May County, located on a peninsula in southeastern New Jersey, is bordered by the Atlantic Ocean on the east and the Delaware Bay on the west. The county is named for Cornelis Jacobsen Mey (later spelled May), a Dutch captain who sailed around her shores between 1616 and 1624 in search of new trading routes. The city of Cape May, originally called Cape Island until it was renamed in 1869, is located at the tip of the peninsula, separated from the mainland by easily forded Cape Island Creek. Beginning in the 1680s, English-speaking farmers and whalers permanently settled in the county, migrating from northern New Jersey, Long Island, and New England. For several centuries before their arrival, the area was home to the Lenni Lenape tribe.

By 1700, four families were living on Cape Island, raising cattle and harvesting crops on farmsteads that ranged from 170 to 300 acres in size. During the Revolutionary War, the island's sugar-sand beaches and salt air had become so popular for recreation that local resident Robert Parsons advertised the sale of a house and 254 acres "open to the Sea . . . and within One Mile and a Half of the Sea Shore; where a Number resort for Health, and bathing in the Water; and this Place would be very convenient for taking in such people." Thus began the oldest seashore resort in the country.

In July 1801, Cape Island resident Ellis Hughes advertised rooms in his public house for people who wanted to bathe in the sea, offering them meals of locally caught oysters and fish accompanied by fine liquors. For other entertainment, Hughes noted that visitors drove carriages along a four-mile stretch of the water's edge, where they watched schooners and other cargo-laden ships that sailed the Delaware Bay en route to and from Philadelphia, located about 70 miles upriver. Hughes also lauded the beaches and proclaimed the area "the most delightful spot the citizens can retire to in the hot season." The season was short, however, lasting from only July 1 to September 1.

Travelers anxious to escape Philadelphia's hot and humid summer had their choice of three ways to get to Cape May in the early 1800s. Some came overland by private carriage, some took a two-day ride by stage that originated in Cooper's Ferry (now Camden), and others found passage on a boat from Philadelphia's busy docks. Regular steamboat service on wood-burning side-wheeler paddleboats between Philadelphia and Cape Island began in 1819. After leaving Philadelphia in the morning, stops were made in New Castle or Wilmington, Delaware, to pick up fuel and passengers, many of them from Baltimore and Washington, DC. Although steep, the $6 fee included an ample breakfast and a noontime dinner of several courses. Cape Island was reached in the afternoon, with passengers disembarking at Steamboat Landing, located at the west end of present-day Sunset Boulevard. Waiting carriages and uncomfortable, springless wagons then relayed passengers and their luggage on a bumpy ride to their final destination.

By 1834, Cape Island boasted six boardinghouses; the largest, Congress Hall, was one block long and fifty feet wide. They were often so crowded that guests were forced to find lodging outside of town and return for meals. These early, wooden hotels were plain in design both inside and out, topped with a gable roof and fronted by a tall veranda supported by wooden posts. Dining rooms were described as large, barnlike spaces. Most boardinghouses had no interior lath and plaster, a luxury that was first introduced when the Mansion House was built in 1832. Cape Island's popularity as a resort continued to grow as competition between steamboat operators dropped the cost of passage.

By the mid-19th century, nearly two dozen hotels, located mostly on three blocks between Perry and Ocean Streets, along with several private residences, offered rooms capable of housing nearly 3,000 summer visitors at a time. A map of the city published in 1850 shows three churches (Baptist, Presbyterian, and Methodist), several stores, a post office, about 60 private residences, a school, an ice-cream parlor, and an Odd Fellows Hall. Sea bathing remained popular, but, with

no lifeguards, drownings were not uncommon. To allay guests' fears, one hotel advertised that it had a lifeboat "always in attendance upon the bathing ground." Other entertainment included billiards, bowling, dances, costume balls, concerts, fishing, promenading along the strand, and even gambling, which was tolerated but never discussed.

In the 1850s, competition from the new seaside resort of Atlantic City (located about 40 miles to the north at the end of a rail line) cost Cape May some of its regular visitors, but the Civil War had an even greater effect. When Cape Island residents pledged their support of the Union in December 1860, they lost a significant amount of business from the thousands of wealthy Southern planters and merchants who had vacationed there every summer for decades. In 1863, however, the long-awaited completion of a rail line from Camden to Cape Island brought renewed optimism and new growth to the resort. Families from Philadelphia and points north began purchasing small lots in town on which they erected summer "cottages," a term used to describe anything from a simple two-room house to an elegant ten-room mansion. New streets were opened, and others were extended, enlarged, and improved.

In 1868, the West Jersey Railroad Company constructed an excursion house near the line's beachfront terminus at Grant Street and Beach Avenue. The three-story building had only a handful of hotel rooms because it catered to a new kind of visitor: the day-tripper, who arrived by train in the morning and returned home by rail in the late afternoon or evening. The next year, Cape Island incorporated as Cape May City and boasted a uniformed police force, a new gas company, and even a racetrack in nearby West Cape May. Business was booming, and the city experienced a renaissance that brought new cottagers, new capitalists with money to invest, and much-needed improvements to existing hotels.

Disaster struck in 1869 when a great fire consumed two blocks in the resort's oldest section. The fire began in the early-morning hours of August 31 in a small Oriental-goods shop on Washington Street. By day's end, three hotels and several commercial buildings on Jackson Street, along with numerous cottages and boardinghouses, were lost; all were built of wood. Except for the Columbia Hotel, spared when the wind shifted, everything in the area bordered by the beach, Washington Street, Ocean Street, and Jackson Street was leveled to ashes.

Only one of the three hotels was rebuilt, and much of the now-barren land was parceled into lots. A three-year-long national depression, begun in 1873, affected Cape May's economy and brought most new construction to a halt. After a prosperous season in 1878, the city once again fell prey to a devastating fire in November. Set by arsonists in the old, closed-for-the-season Ocean House on Perry Street, the fire quickly traveled to nearby Congress Hall, fanned by 35-mile-per-hour winds. The city's antiquated fire apparatus was woefully inadequate, and little could be done as the flames jumped from one wooden building to next. By 4:30 that afternoon, the fire was declared under control, but 35 acres of important oceanfront real estate in the heart of Cape May had burned to the ground, this time destroying seven hotels, more than 30 cottages and rooming houses, and about 2,000 bathhouses. The burned-out area stretched from Gurney Street to Congress Street.

Increased competition from Newport, Atlantic City, and other, more modern seaside resorts greatly influenced Cape May's rebuilding efforts. Congress Hall was reconstructed as a smaller version of its original L-shaped design, but in brick. Several new hotels were styled after traditional designs popular a generation or two earlier and consequently had a more old-fashioned look. While some new cottages were architect-designed, the majority were constructed by local carpenters who copied popular designs from pattern books of the day. Thus, Cape May maintained its small-town atmosphere even as reconstruction proceeded on the burned-out oceanfront lots. The new buildings embraced a wide range of Victorian styles that included Queen Anne, Italianate, Second Empire, and Folk Victorian. Most featured wide, bracketed porches embellished with carved "gingerbread" trim.

A second rail line, this one operated by the South Jersey Railroad, was run into Cape May in 1894. In several places, its tracks ran parallel with those of the West Jersey; races between the two lines often ensued. The new line brought more visitors, which led to more hotels and cottages.

By the early 1900s, Cape May was enjoying renewed popularity, offering guests a new iron pier and a new (but short-lived) ferry service between Cape May and Lewes, Delaware.

In 1903, a group of businessmen from Philadelphia and Pittsburgh incorporated the Cape May Real Estate Company, seeking to transform a 3,500-acre undeveloped section of Cape May located east of Madison Street. The syndicate planned houses on a 7,500-lot subdivision, a brick hotel with every modern amenity, and a 600-acre harbor that would be created by a gigantic dredge. The boardwalk was extended, new streets were created, and the Hotel Cape May opened in 1908; however, relatively few houses were built. The syndicate went bankrupt shortly thereafter, and Nelson Z. Graves, a Philadelphia businessman who had been one of Cape May's longtime cottagers, bought the development. Graves built an amusement casino, dubbed the "Fun Factory," on Sewell's Point at the easternmost edge of the development and also completed dredging the harbor. He, too, went bankrupt, and the grand project stalled. The eastern third of the property was then acquired by the US Navy during World War I. Today, the site is home to the US Coast Guard Training Center.

As the automobile changed the way tourists vacationed, Cape May entered a slow decline. Growth was hindered by both its location at the southernmost tip of New Jersey and by an inadequate road system, which made it difficult to access by car. As a result, several of the old, large hotels were torn down and replaced with smaller-scale ones. With less passenger traffic, the two rail lines merged in 1933, but the Great Depression dashed any hopes for Cape May's revitalization. Wholesale lack of interest in the city after World War II preserved the majority of its older buildings, and demolition was rare. Even the completion in 1954 of the 173-mile-long Garden State Parkway, which connected the major population centers in northern New Jersey with southern New Jersey's tourist destinations, failed to bring the crowds back to the city that had once been called the "queen of seaside resorts." However, several local residents began to argue that Cape May's long history and its historic buildings should be capitalized on as a way to attract visitors, and, when a grassroots taxpayer's revolt brought in a new city government in 1960, the seeds of change were sown.

A sustained, three-day nor'easter in March 1962 pounded Cape May's already-eroded beaches, leveled most of the boardwalk, damaged several buildings beyond repair, and brought widespread flooding unlike any experienced before. As the city rebuilt, momentum grew to use its history not only as a way to bring vacationers back, but to extend the season by offering tourists an alternative to the beach. A $3 million urban-renewal grant in 1962 created a "Victorian Village" of restored buildings and encouraged downtown revitalization by forming the pedestrian-only Washington Street mall. Accommodating car traffic was more problematic, however, since the city's narrow streets had little room for parked cars. Thus, the massive lawns of two of the largest hotels (Congress Hall and the Windsor) were paved over, and a train station in the heart of town was demolished to create a parking lot. Several oceanfront cottages were moved and replaced with modern, air-conditioned motor lodges.

By the 1920s, African Americans composed about 30 percent of Cape May City's total population and owned more than 60 businesses. Their contributions to Cape May's economy and culture continued until the 1960s, when numerous African American families and businesses were displaced, including both property owners and renters, during urban renewal. Only the predominately black section of town was demolished and was replaced with parking lots, open space, and public housing.

As residents struggled to find the right balance between preserving historic buildings and encouraging modern development, most of the city was listed in the National Register of Historic Places in 1970. This prevented the use of federal funds for the demolition of any historic building. However, battles ensued over what to preserve. The Mid-Atlantic Center for the Arts was formed in 1970 to save and restore the 1878–1879 Emlen Physick Estate, one of the city's finest Victorian-era mansions. The city reneged on its promise to accept a Housing and Urban Development grant for the building's restoration, but a new mayor reversed the decision. The house museum today is one of the city's premier visitor destinations.

In 1976, the historic district was declared a National Historic Landmark, the highest national designation possible, recognizing it as the best single, unified area of Victorian-era architecture east of the Mississippi River. Around this time, a handful of owners decided to convert their cottages into bed-and-breakfasts that catered to the traveler's desire to stay in an authentically restored and furnished house. Others followed suit, building on the early success of the pioneer innkeepers; today, the city boasts more than 50.

In addition to providing summer visitors a world-class beach, Cape May today offers exciting new programs, festivals, and specialty tours that extend the season from April through December. These have been enhanced with other nearby heritage tourism sites, including the Cape May lighthouse, a World War II lookout tower, the open-air living history museum of Historic Cold Spring Village, and Naval Air Station Wildwood Aviation Museum.

One

HUMBLE BEGINNINGS

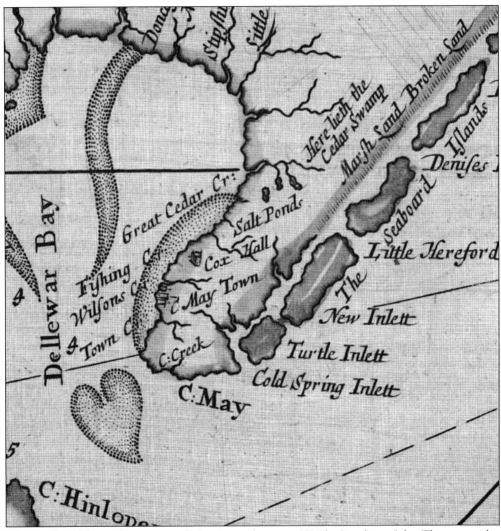

This is a detail from a larger map of New Jersey drawn in 1706 by Londoner John Thornton, who used surveys made by Englishman John Worlidge. This section shows the Cape May peninsula, its barrier islands, and major creeks. At the tip are "C: May" (Cape May) and "C: Creek," which probably refers to Cape Island Creek. The building called Cox Hall and those shown in "C[ape] May Town" no longer stand. (LOC.)

As part of the 350th anniversary celebration of Henry Hudson's voyage from Amsterdam to North America in 1609, a replica of his 63-foot-long Dutch ship *Half Moon* was anchored off of Cape May for the summer of 1959. This small ship was copied after the one that Captain Hudson and his 18 Dutch and English crewmen sailed on their journey to the New World, a trip financed by the Dutch East India Company. In August of that year, Hudson's explorations took him along the coast of New Jersey, where his senior officer, Robert Juet, noted their discovery of a "great bay and rivers." However, the Delaware Bay was full of shoals and was so shallow that their 122-ton boat struck bottom. Hudson did not land here, and they ventured no further up the bay, likely reasoning that the shallow waters were not the fabled Northwest Passage they sought. This replica, which sustained some damage to her masts after a storm, was part of a summer-long program of celebrations in Cape May called Henry Hudson Days. (CMCHGS.)

The road from northern Cape May County south to Cape Island, as the city of Cape May was known until 1869, was laid out in 1706. At various times, it was called the Queen's Road, the King's Road, or Old Cape Road. Stone markers like this one were placed every mile along the path, announcing how far the traveler had yet to go before reaching "CI," or Cape Island. (LOC.)

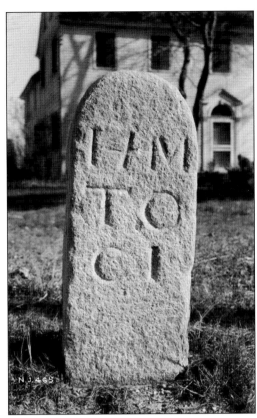

One of the oldest houses still standing in Cape May is the Blue Pig, a pre–Civil War gambling establishment that originally stood on the lawn of Congress Hall. Despite its Victorian-era appearance, the house was actually built between 1710 and 1730 by George Hand, whose father, Thomas, bought 340 acres on Cape Island in 1699. Thomas Hand, like many county settlers, was a whaler from Long Island. (NASW.)

One-room fishing shacks like this one were common along the county's unsettled barrier islands before they became resorts. The first shacks were erected by the earliest settlers, who hunted for whales in the winter months, camping in small buildings as they watched the shoreline for their prey. A valuable commodity, whales were prized for the oil extracted from their blubber and were hunted to near extinction by the mid-1700s. (CMCHGS.)

Although this c. 1900 photograph shows an unnamed beach in Cape May County, it accurately illustrates how desolate the original landscape was along the oceanfront. Sprung from little more than sand dunes and beach grass, the resort of Cape May City grew to be called the undisputed "queen of the seaside resorts" by the Civil War. (CMCHGS.)

Two

HOTELS AND OTHER ACCOMMODATIONS

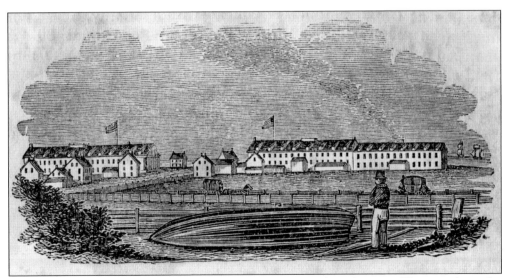

The earliest image of Cape May's first hotels is this 1844 line drawing. The view faces the ocean, where two tall ships sail. Shown are several two-story private residences, many of which accommodated visitors in the summer months, as well as two of the city's four hotels. Their plain, bland architecture was typical of the resort's early lodging. (NASW.)

TREMONT HOUSE
CAPE ISLAND, N. J.

Erected sometime before 1850, the Tremont House (below) was one of the city's earliest boardinghouses. Offering 125 guest rooms, the building stood at the corner of Franklin and Washington Streets and was torn down at the turn of the last century. According to its rules and regulations (left), printed sometime in the 1850s, rooms cost $1.50 per day, or $9 for the week, and included three meals a day. By 1868, rooms were $2.50 a day, or $15 per week. The rules also asked guests to write their names on a slate the day before leaving, noting the boat they intended to take. This allowed the proprietor to order the right number carriages to take them and their luggage to Steamboat Landing for departure. (Both, CMCHGS.)

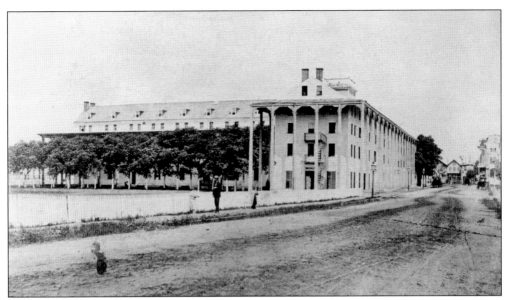

The Columbia House, seen here about 1875, was completed in 1846 and straddled the oceanfront block between the newly opened Ocean and Decatur Streets. Its expansive front lawn was 400 feet from the surf, giving the hotel unobstructed views of the ocean. Although the Columbia House escaped the 1869 fire, it was consumed in the Great Fire of 1878. (CMCHGS.)

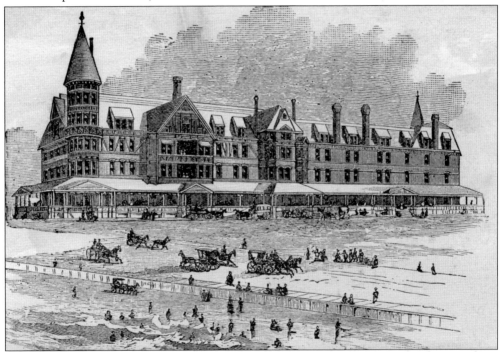

Owner James Mooney hired Philadelphia architects John Deery and James Keerl to design the New Columbia Hotel in the fashionable Queen Anne style in 1878. With its corner tower, arch-headed windows, and projecting gables, the 160-room hotel was unlike Cape May's traditional boxy ones. In 1888, it advertised "first-class appointments, electric bells, gas lights, and an elevator." The hotel was short-lived, burning to the ground in October 1889. (CMCHGS.)

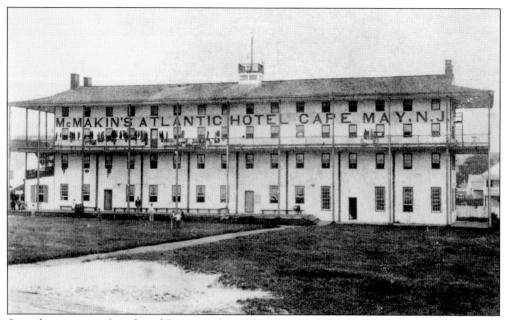

Steamboat captains Joseph and Benjamin McMakin from Philadelphia built the Atlantic Hotel in 1842, fronting the ocean at Jackson Street. Capable of accommodating 300 guests, the four-story, boxlike structure featured a large dining hall that occupied most of the first floor. The proprietors cleverly painted the name of their establishment in tall, prominent letters visible to anyone on a passing ship. It no longer stands. (CMCHGS.)

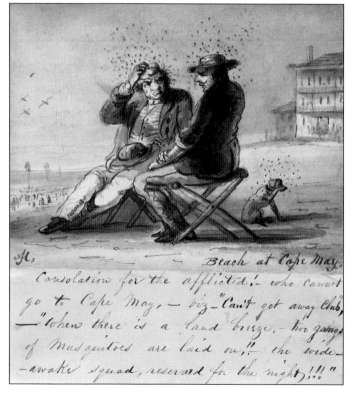

American artist Alfred J. Miller painted this depiction of mosquitoes plaguing two visitors and their dog as they sat in front of one of Cape May's hotels in the 1840s. The biting insect was an unwelcome visitor when the wind blew off the land rather than the water. It was not until the early 1900s that the county formally established a mosquito-control commission to eradicate the pest. (Walters Art Museum, Gift of Mr. and Mrs. Decatur H. Miller, 1994.)

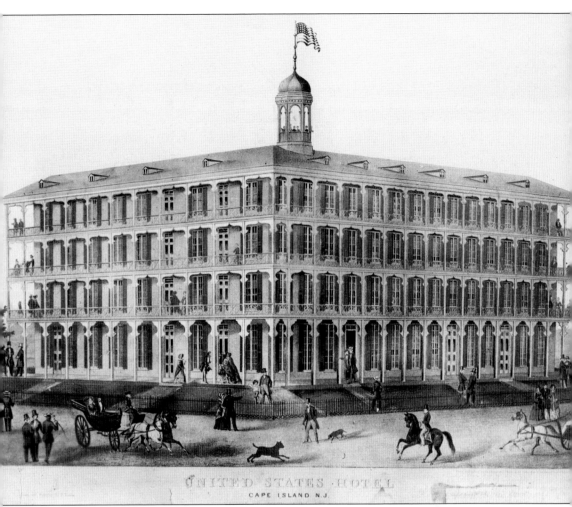

UNITED STATES HOTEL
CAPE ISLAND N.J.

The massive and handsome four-story United States Hotel was built on a 10-acre lot at the corner of Washington and Decatur Streets by wealthy Philadelphian Ayers Tompkins. It opened for its first summer season in 1850, accommodated 400 guests, and offered stabling for those wishing to bring their own horses and carriages. Tompkins often described the building in newspaper advertisements as an "airy and commodious Hotel of summer entertainment." Wide verandahs offered cool breezes on hot summer days and afforded most rooms with a view of the ocean. The establishment's popular and patriotic name was shared by other hotels in Philadelphia, Baltimore, and in the competing resort of Saratoga Springs. Within the first two months of operation, it had suffered four minor fires that were deliberately set but were quickly extinguished. The scoundrel was never apprehended, and no fires were reported in subsequent seasons. Unfortunately, the hotel succumbed to a devastating fire in 1868 and was never rebuilt. (CMCHGS.)

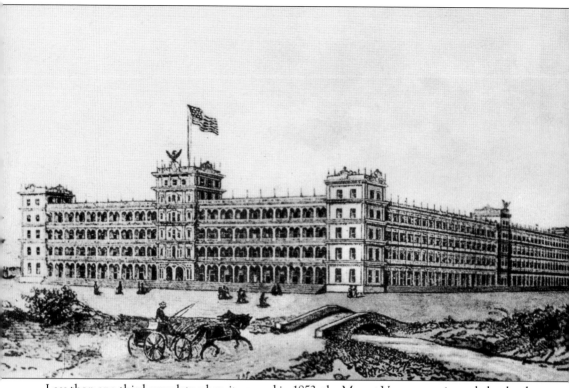

Less than one-third complete when it opened in 1853, the Mount Vernon was intended to be the largest hotel in the world. With 3,500 rooms, the four-story structure was designed to handle at least 7,000 guests in its main building and its 506-foot-long wings. According to newspaper accounts, each bedroom was equipped with its own bathroom, a novelty at the time, and the bathrooms featured both hot and cold running water. The entire building, lit by gas manufactured on the premises, was said to contain 125 miles of gas and water pipes. Men and women had separate drawing rooms filled with furniture described as "costly and ornate." The dining room was 400 feet long by 60 feet wide. The hotel's projected cost was $300,000, a huge sum at the time. In addition to surfside bathing houses for use by patrons, "bathing cars" were provided for invalids who had difficulty walking to the beach. The hotel burned to the ground in 1856 and was never rebuilt. (CMCHGS.)

OPPOSITE PAGE: The Lafayette Hotel, erected in 1884, was designed by noted Philadelphia architect Steven Decatur Button, who designed three of the city's four major waterfront hotels built after the Great Fire of 1878. Sited at the foot of Decatur Street, it contained 125 rooms placed in an L-shaped format to maximize the number of rooms with an ocean view. The Lafayette was demolished in 1970. (LOC.)

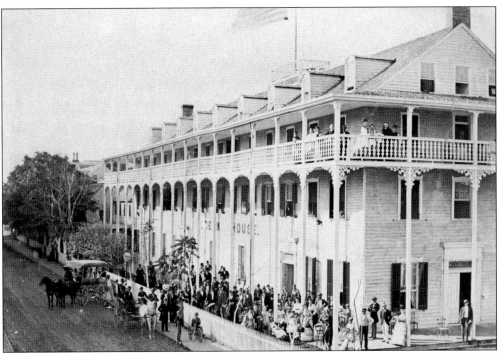

Built in 1856 on Perry Street, opposite Congress Hall, the Ocean House held 400 guests. At the beginning of the 1877 season, its owners spent more than $30,000 refurbishing the entire hotel. Fully insured, it burned to the ground in the Great Fire of 1878. Because the fire started in the Ocean House, some newspaper accounts claimed that its proprietor, S.R. Ludlam, was the arsonist, but he was never charged. (CMCHGS.)

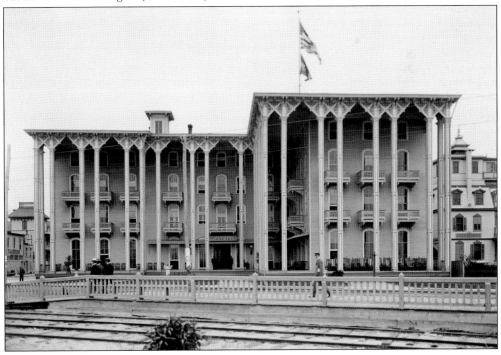

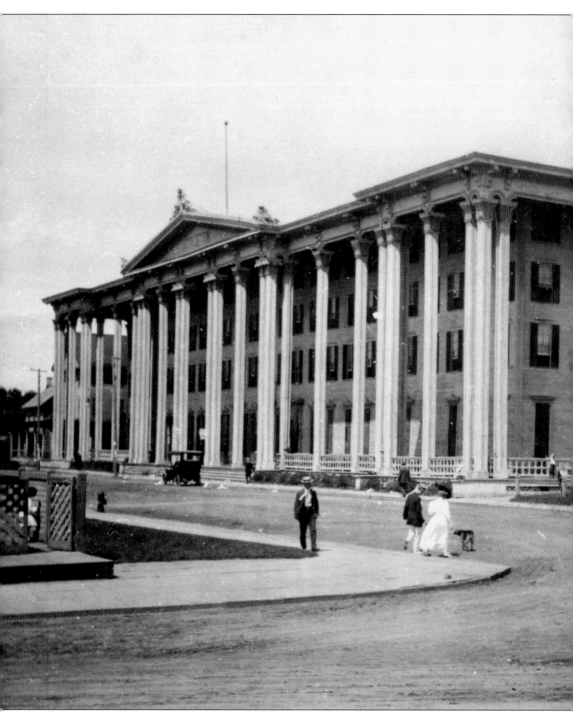

The mammoth Stockton Hotel occupied a choice oceanfront block between Gurney and Howard Streets that was created by filling in marshland. Designed by Philadelphia architect Steven Decatur Button, the hotel was built by the West Jersey Railroad in 1869 at a cost of $300,000 and offered overnight accommodations in 475 guest rooms. Its dining hall seated 800 at one time. The local newspaper reported on the progress of its construction, noting that 25,000 pounds of

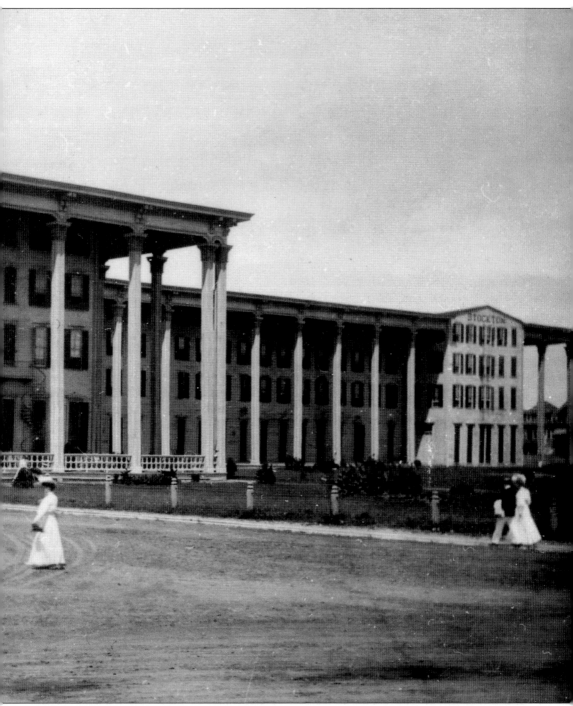

iron were used throughout the building and the labor cost between $3,000 and $4,000 a week. The inaugural ball featured a "handsome supper" at 10:00 followed by fireworks on the front lawn. Financial problems plagued the building's original and subsequent owners, and the hotel was torn down in 1910. (CMCHGS.)

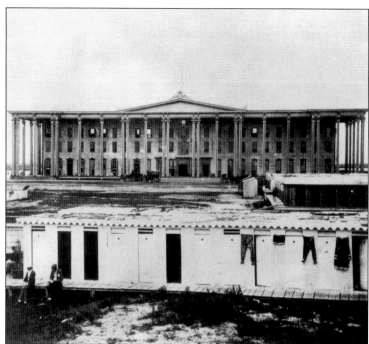

Bathhouses, like these in front of the Stockton Hotel, were typically simple one-story wood structures built along the water's edge. Tiny cubicles on the inside, they provided a convenient place for changing into and out of bathing costumes. Often, a colored flag was flown on top during bathing times, white to signify women's hours and red for men's hours. (CMCHGS.)

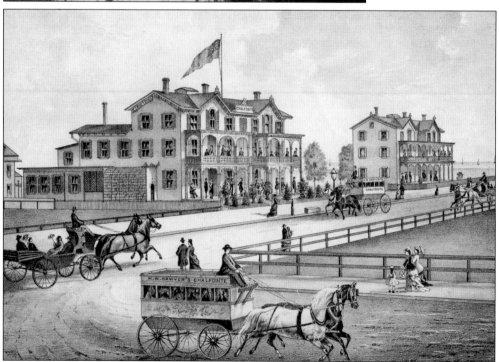

The Chalfonte, seen in this 1878 drawing, still stands on Howard and Sewell Streets. It was built in 1876 by Col. Henry Sawyer, a Civil War hero who was slated to be executed by the Confederates in 1863. His life was spared, however, when Pres. Abraham Lincoln interceded and had Sawyer exchanged for Gen. Robert E. Lee's son William, who had been captured and was being held in a Union prison. (CMCHGS.)

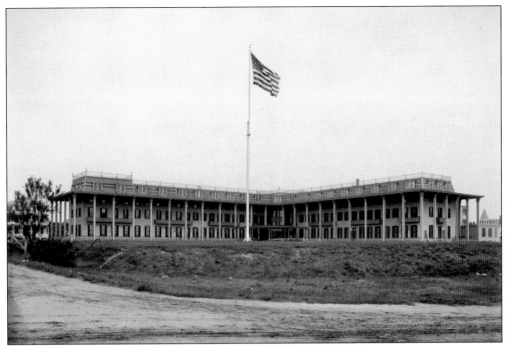

The present Congress Hall, built in 1879, is the third building of that name on this site. The first was built in 1816 and the second, erected in the 1850s, was lost in the Great Fire of 1878. Unlike its predecessors, the new hotel was built of fireproof brick, but its L-shaped design remained very traditional. Note the sandy, unpaved streets in this 1900 photograph. (LOC.)

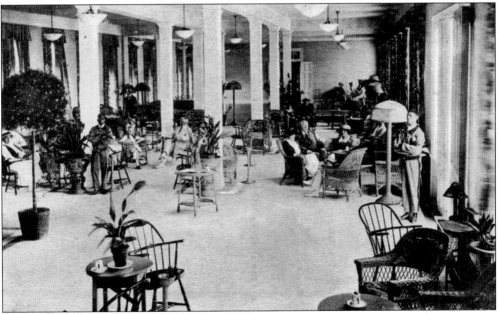

The lobby in Congress Hall, seen here in a 1920s postcard, featured reproduction Windsor chairs mixed with wicker, potted plants, standing lamps, and pedestal ashtrays. African Americans, dressed in the hotel's uniform, stand in attendance. Floor-to-ceiling windows on both sides of the lobby opened to allow the flow of cooling ocean breezes. (DP.)

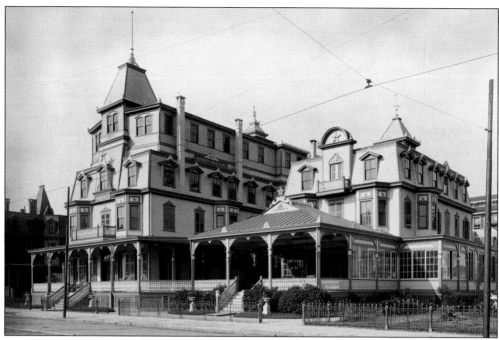

Star Villa, seen here about 1910, opened for business on Ocean Street the summer of 1885 with 40 rooms in a two-part, three-story building that looked more like a large cottage than a hotel. The fourth story was added in 1893. Star ornamentation was used as a motif over the windows, in the porch balusters, and even in the wicker furniture. It was moved to East Cape May in 1967. (LOC.)

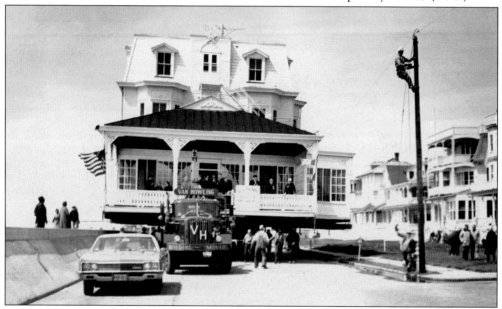

Both sections of Star Villa were moved down Beach Avenue in 1967 by Rev. Carl McIntire, who played an important role in the city's revitalization. The larger, four-story part still stands on Beach Avenue, near Trenton Avenue; it was so heavy that its weight caused the road to collapse during the move. The shorter section seen here was placed behind it, but it was subsequently torn down. (CMCHGS.)

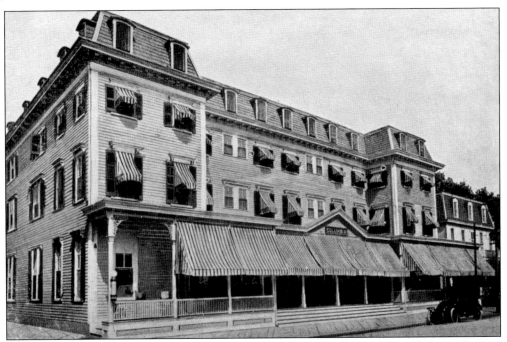

The Columbia Hotel was located on Ocean Avenue between Hughes and Washington Streets. Originally called the Arctic and renamed at the end of the 19th century, it boasted a mansard roof, 100 rooms, a parlor, and a dining room. Newspaper advertisements touted the piano used for entertainment. The hotel was torn down in the 1960s and replaced with the present Victorian Towers apartment building. (CMCHGS.)

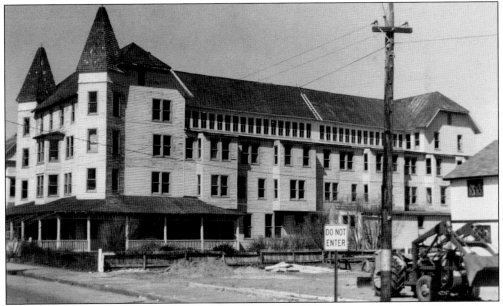

The twin-towered Baltimore Inn, seen here in disrepair in 1964, was completed in 1893 on Jackson Street. It was designed and built by local architect Enos Williams and featured 88 guest rooms. Williams cleverly put the hotel's enormous ballroom on the top floor, where views of the ocean were unobstructed by neighboring buildings. The inn was demolished in 1971. (CMCHGS.)

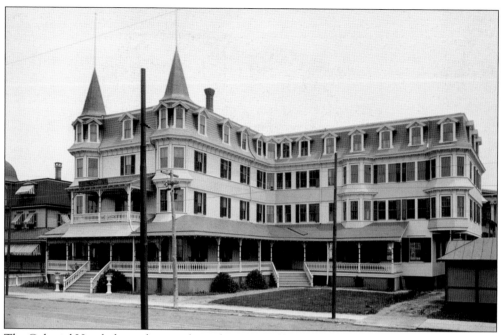

The Colonial Hotel, shown here in the early 1900s, still stands on Ocean Street just above Beach Avenue. It was designed and built in 1894 by its owners, William and C.S. Church, who were also contractors. William was the hotel's proprietor for a number of years. The building's twin towers and mansard roof recall other city hotels built in the same period. (CMCHGS.)

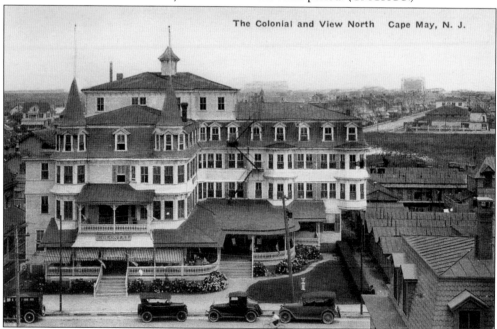

This photograph of the Colonial Hotel was taken in the 1920s from a building across the street. In the distance to the right is the 1913 Marine Casino, a venue for music, dancing, and talking pictures. The adjoining Dutch mill was also part of the complex; it later became a members-only club not open to the general public. (DP.)

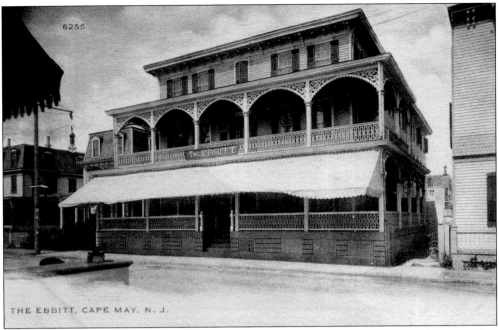

THE EBBITT, CAPE MAY, N. J.

The Ebbitt House, which still stands on Jackson Street, was erected in 1879 to replace an earlier building on the lot that burned down in the 1878 fire. It was one of the first hotels on Jackson Street to be rebuilt after the fire. Local builder and architect Enos Williams designed the building for its owner, Alexander McConnell, who chose a simple, bracketed villa ornamented with lavish gingerbread trim on the first- and second-story wraparound porches. By the early 1900s, it was renamed the Virginia Hotel and was probably remodeled about that time with the Colonial Revival porches seen below. The hotel was restored to its original appearance in the 1980s and today has 24 guest rooms. (Both, DP.)

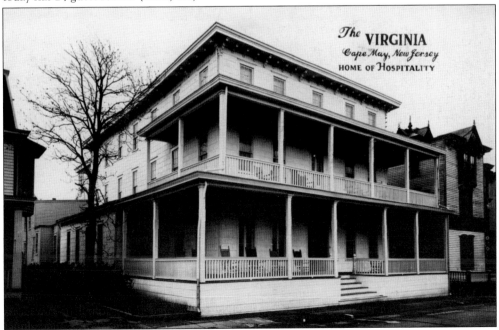

The VIRGINIA
Cape May, New Jersey
HOME OF *Hospitality*

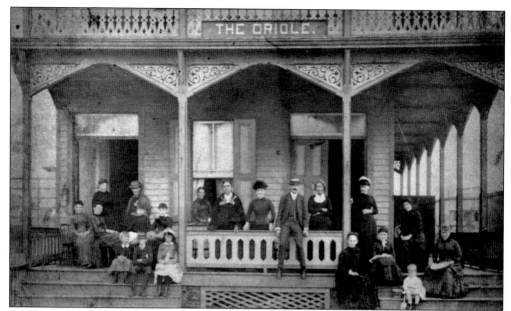

The Oriole, seen here in the late 1800s, was built in 1879 near the foot of Perry Street, where it still stands. It was probably one of several guesthouses that offered more homelike accommodations to the Cape May visitor. Maps from the time show many such buildings, with names like Ocean View, Griffith Cottage, Adele Cottage, Saint Anthony's Cottage, and Seabrook Cottage. (CMCHGS.)

The Windsor Hotel, seen here about 1910, was created in 1879 when Thomas Whitney took his existing oceanfront cottage and added two wings to it. Electric elevators were added in 1913. In the 1960s, the hotel's massive front lawn was converted into a parking lot. The unoccupied Windsor burned to the ground in May 1979 in a suspicious, two-hour-long fire that could be seen 30 miles up the coast. (LOC.)

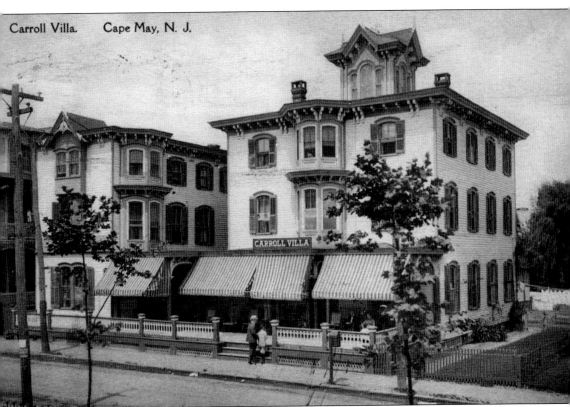

Carroll Villa. Cape May, N. J.

Built in 1882 on Jackson Street, where it still stands, Carroll Villa was designed and built by local architect Charles Shaw for George Hildreth, former owner of two Cape May hotels and whose cottage on South Lafayette Street burned down in the 1878 fire. By the 1880s, approximately one-half of Cape May's visitors were from Baltimore. Hildreth, hoping to attract guests from that city, named the villa for Baltimorean Charles Carroll, a signer of the Declaration of Independence. Carroll Villa was among the first of Cape May's hotels and boardinghouses to stay open year-round, a trend that began after the Great Fire of 1878. The boardinghouse was several blocks from the beach, but the cupola on top afforded spectacular ocean views. The porch was enlarged and remodeled in 1892; in 1895, a new wing containing a dining room on the first floor and winterized sleeping quarters on the upper stories was erected on the building's north side. That wing is seen here to the left of the main building. (DP.)

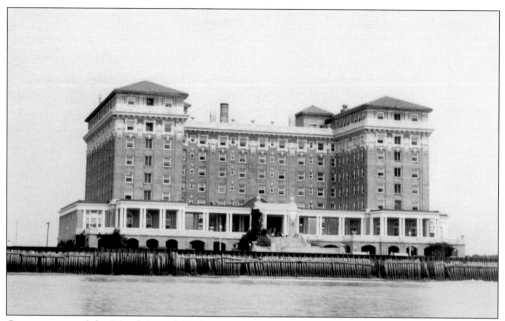

Construction of the Hotel Cape May began in 1905, but was not completed until 1908. Erected at a cost of $1 million—nearly twice the estimate—it featured 350 rooms, grand lobbies, elegant staircases, and several dining rooms. The hotel anchored a residential development scheme in East Cape May that failed just one year later. Demolished in 1996, it was used as a military hospital during World War I. (CMCHGS.)

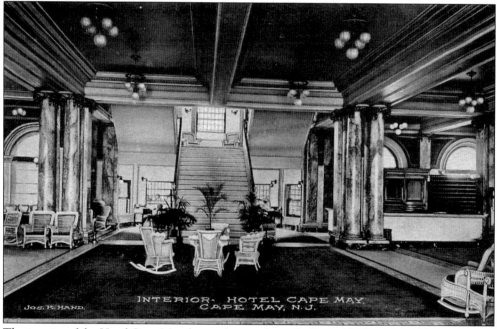

The interior of the Hotel Cape May featured a grand stair hall, marble floors, marble wainscot in the lobby, and coffered ceilings enriched with a variety of moldings. The grouped columns seen here were actually made of iron and painted to simulate marble. A Tiffany-style dome lit the lobby, and the hotel boasted a rooftop garden "like that of the Hotel Astoria" in New York City. (DP.)

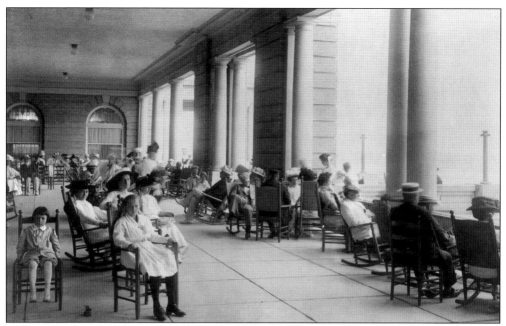

Guests young and old enjoyed the ocean breezes that washed over the piazzas of the Hotel Cape May. The hotel, which faced the ocean, had two verandas that also offered protection from the hot summer sun. Despite its luxury appointments, the hotel never made a profit for its many owners, and it was demolished in 1996 after its last owner, Rev. Carl McIntire, filed for bankruptcy. (LOC.)

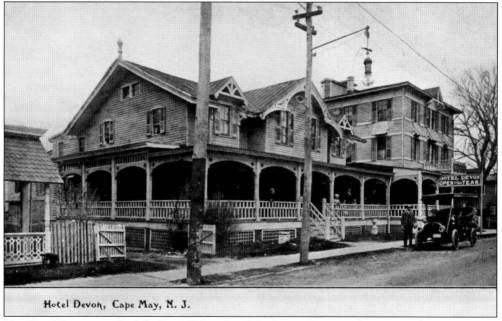

Hotel Devon, Cape May, N. J.

The Hotel Devon was built before 1890 on South Lafayette Street and appears to be two separate cottages joined to make one hotel. It had a total of 50 guest rooms and also offered meals. In a 1913 advertisement, the hotel noted it had moderate rates of "$1.50 per day and up" depending on the location of the room, with special rates by the week. (DP.)

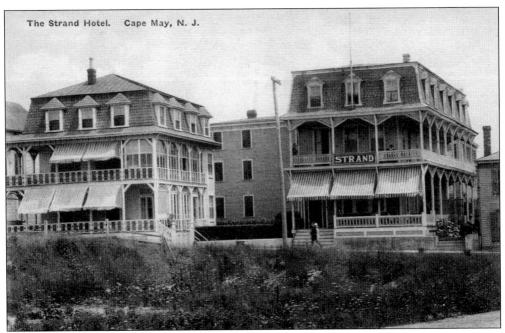

The Strand Hotel. Cape May, N. J.

Built after the Great Fire of 1878, the Strand Hotel (right) still stands near the foot of Perry Street, where it is now known as the Sea Villa bed-and-breakfast inn. The hotel has had several names over the years. At left in this c. 1920 photograph is a two-and-one-half-story private house known as Fryer's Cottage, built in 1879. It also still stands. (DP.)

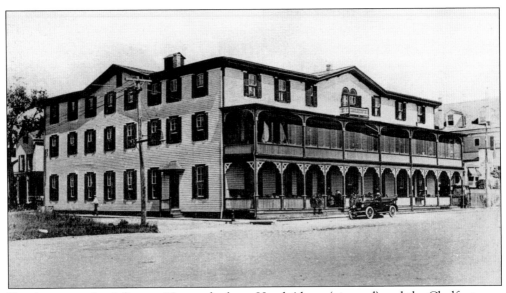

First known as the Arlington House, the large Hotel Alcott (pictured) and the Chalfonte are the only two hotels that survive from the years before the Great Fire of 1878. Built that same year and later known as the Huntington House, it has been extensively restored and continues to operate as a hotel. It stands on Grant Street, opposite the original location of the demolished Pennsylvania Railroad summer station. (DP.)

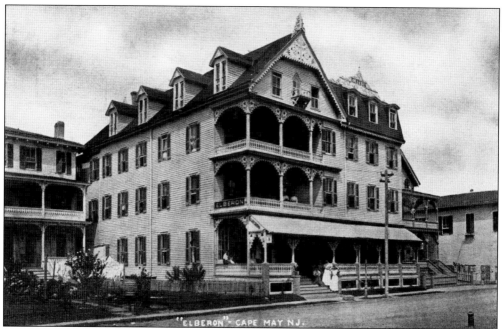

The Elberon, seen here about 1908, was built for Eldredge Johnson in 1884 as a boardinghouse and stood on Congress Avenue opposite Congress Hall. The lot originally contained the Congress Hall laundry building. The Elberon was demolished in the 1960s as part of Cape May's urban-renewal plan to make way for a modern, three-story motor lodge. (DP.)

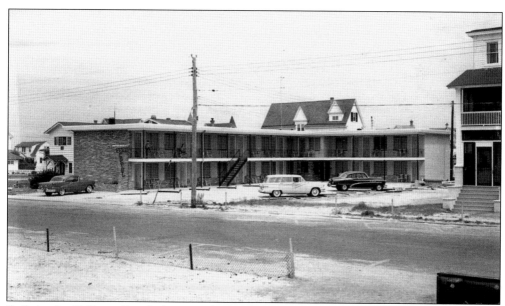

Built in the 1950s on Beach Avenue, the Surf Motel offered motoring vacationers rooms that opened directly onto an ample parking lot. Few of Cape May's Victorian-era hotels featured such convenient parking. This motel was typical for the time period, having an L-shaped footprint and a balcony fronting its second-story rooms. (CMCHGS.)

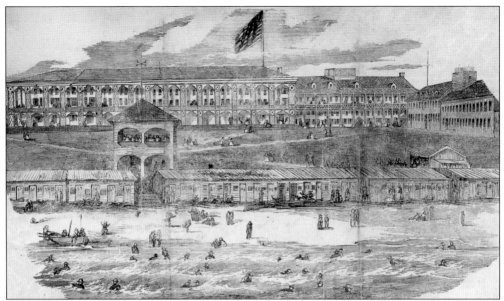

In the 1850s, an artist sketched this rendering of Congress Hall as it appeared before burning to the ground in 1878. Built in 1816 by Thomas Hughes and later expanded, it was originally known as the "Big House" before being renamed Congress Hall in 1828. Summer visitors did not seem to mind its lack of plaster interior walls or its unpainted exterior walls. (CMCHGS.)

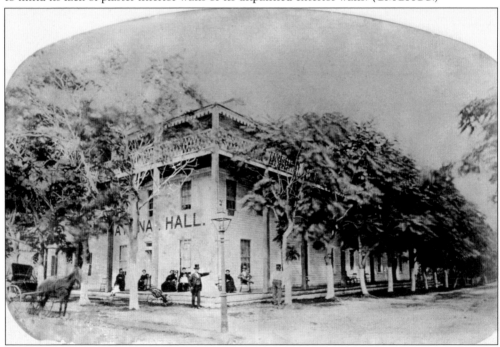

Aaron Garretson built National Hall, which no longer stands, in the spring of 1851 at the northwest corner of Corgie and Franklin Streets. Advertising for customers that summer, Garretson boasted of the hotel's elegant furnishings, new linens, and its "magnificent view of the ocean." Large enough to accommodate 300 people, its simple, boxlike design embellished with wraparound porches was typical of Cape May's hotels at the time. (CMCHGS.)

Three

COTTAGES

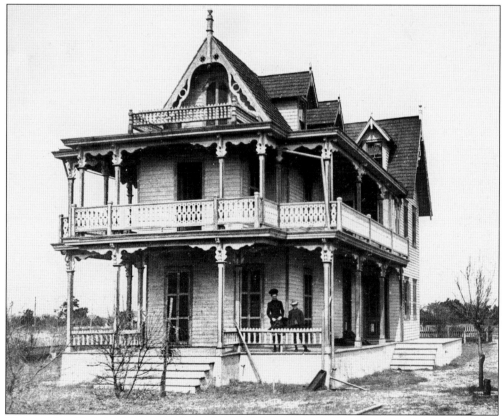

This unidentified dwelling, seen here about 1900, is typical of Victorian-era cottages built in Cape May during the last half of the 19th century. Its expansive wraparound porches feature two different styles of railings, and the porch columns are topped with flat, jigsaw-cut moldings. Tall, floor-to-ceiling windows on the first story open to catch sea breezes. Even the dormers and the front-facing gable are decoratively trimmed. (CMCHGS.)

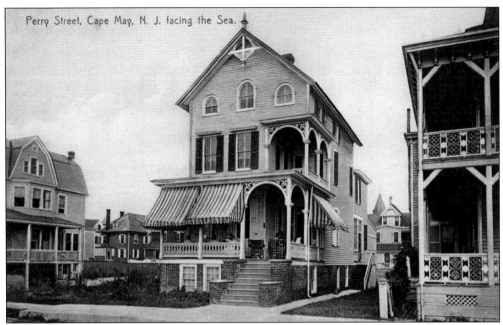

Built for an unknown client in the early 1900s, this gable-front cottage still stands near the foot of Perry Street. Some of its original details have been changed, including the gingerbread-trimmed porches, but it is still recognizable. On the 1909 Sanborn map, it is labeled as having apartments; these were probably rented by the week. Seen on the right is Fryer's Cottage. (CMCHGS.)

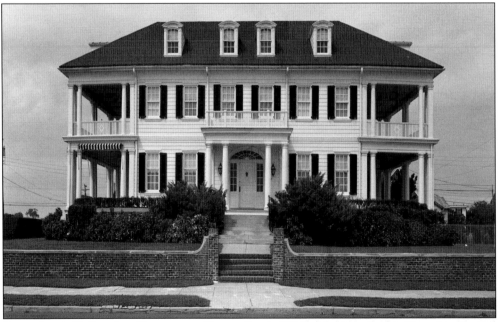

Pennsylvania Railroad traffic manager George Boyd of Philadelphia built this Georgian Revival summer cottage in 1911 on Beach Avenue, where it still stands. Seen here in 1977, it was designed by Philadelphia architect Frank Seeburger, whose offices were in the same railroad-owned complex in which Boyd worked. The interior features an elegant, grand staircase in the center hallway. (LOC.)

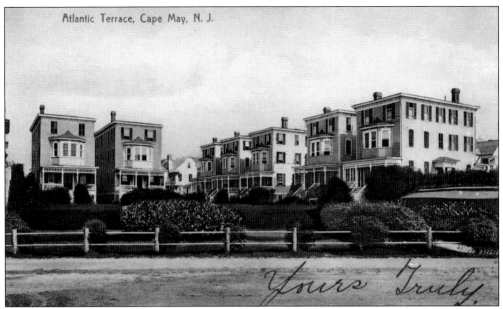

This group of seven single-family cottages was built in 1892 on the site of McMakin's Atlantic Hotel, which burned down in the 1878 fire. They were designed by Philadelphia architect Stephen D. Button, whose plan of grouping them around a court was a novel idea for Cape May at the time. Standing between Jackson and Perry Streets, each cottage had a spectacular view of the ocean. All survive today. (DP.)

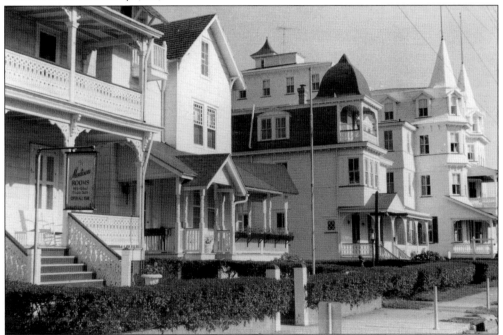

These three cottages share the east side of Ocean Street with the Colonial Hotel (far right). All were new buildings erected before 1900 on the site of those that burned down in the 1878 fire. The photograph was taken in the fall of 1961, when Cape May was still an old-fashioned seaside resort that had yet to be rediscovered. All four still stand. (CMCHGS.)

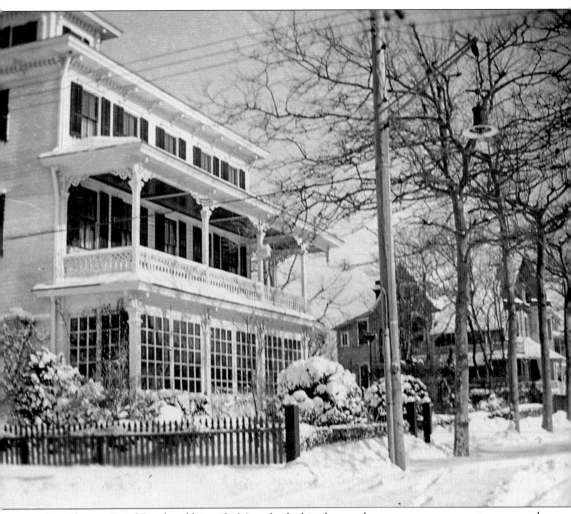

Dr. Thomas Baird Reed and his wife, Mary, built this elegant three-story summer cottage around 1886. It still stands on Lafayette Street between Elmira and Decatur Streets and today is a popular bed-and-breakfast that also offers dinner theater. This view was snapped on a snowy winter day in February 1930. The Reeds' house is a classic example of the Italianate style, complete with bracketed cornices, porches trimmed with wooden gingerbread details, and a cupola on top of the roof that offered a stunning view of the resort. This style dominated American architecture between 1840 and 1880. When not summering in Cape May, the Reeds lived on Walnut Street in Philadelphia, where he was a surgeon affiliated with Pennsylvania Hospital. During the Civil War, he served as a Union physician and medical inspector under Gen. George McClellan in the US Army. (CMCHGS.)

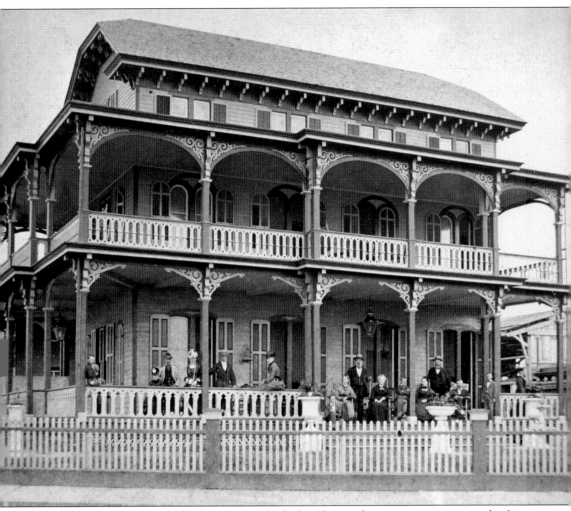

Philadelphians William and Catherine King built this elegant three-story cottage near the foot of Jackson Street in 1877. William King, originally in the drugstore business, left that line of work and became an oil merchant, operating his business on Arch Street in Philadelphia for 40 years. He also owned several rental cottages in Cape May near the foot of Decatur Street. Both Kings were active in charity work; Catherine was president of the Seaside Home, a hotel-type structure offering vacations to women and children of limited means, operated by Philadelphia's Presbyterian Orphanage located in nearby Cape May Point. Here, the King family gathers on the front porch. The only identified person is Catherine King's sister, Louisa Foster Mather, wearing the dark dress and seated under the hanging lamp. The house burned to the ground in the 1878 fire. (CMCHGS.)

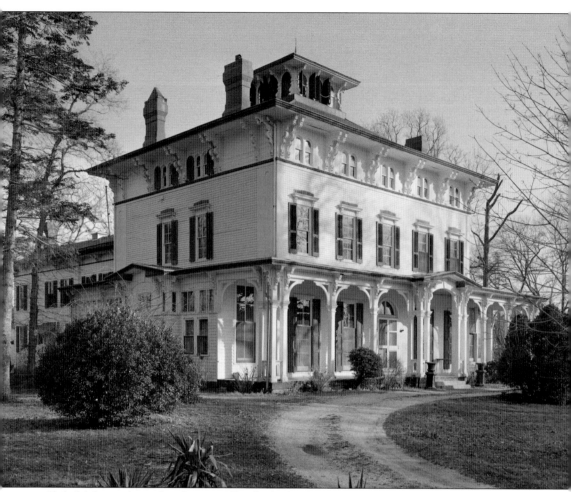

Philadelphia industrialist George Allen built this house in 1864 at the then-staggering cost of $6,000. Facing Jefferson Street and occupying half of the city block between Washington and Corgie Streets, it was designed by eminent Philadelphia architect Samuel Sloan, who later published a design for a nearly identical house in his 1868 book *The Model Architect*. The cupola-topped house was occupied by Allen and then his descendants until 1946, when it and its contents were sold that year for $8,000. Converted into a boardinghouse, the Italianate Villa mansion suffered from neglect and delayed maintenance over the next 40-plus years. The current owners purchased it in 1994 and embarked on an 18-month project that involved significant structural repairs, the installation of new wiring, plumbing, and HVAC systems, and restoration of all of the original interior and exterior elements, which thankfully remained. The house is currently a bed-and-breakfast known as the Southern Mansion. (LOC.)

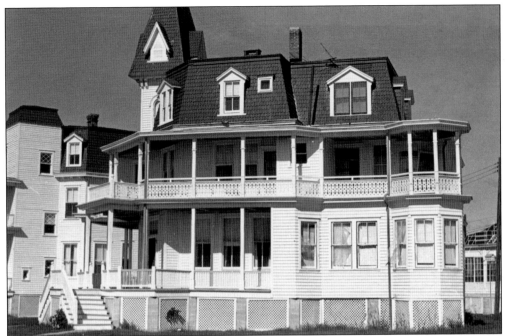

Weightman Cottage, seen here in the 1960s, was built about 1860 for Philadelphian William Weightman. In 1881, the cottage was moved in two pieces to Ocean Avenue, cut in half because it was too large to transport as one unit. From there, the now-separate cottages were taken to their present site on Trenton Avenue in 1963. They have since been restored and converted into a bed-and-breakfast. (CMCHGS.)

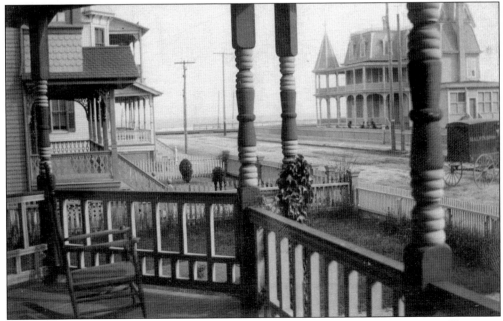

Viewed from the porch of a neighboring cottage is the Weightman Cottage at its second location, the corner of Ocean and Beach Avenues. The Halpin Brothers' buggy (right) belonged to Thomas and John Halpin, who operated a grocery store in the city in the early 1900s. (CMCHGS.)

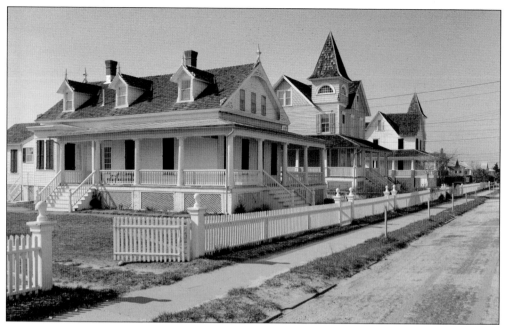

Featured in this picturesque streetscape is the c. 1900 Hertzberg family cottage at 8 Broadway. The two houses to the right were originally located in South Cape May, a small resort a dozen blocks to the west established in 1894. Storms ravaged the area, and, by the 1950s, less than 20 of its buildings remained. These two houses were moved from there around 1954. (LOC.)

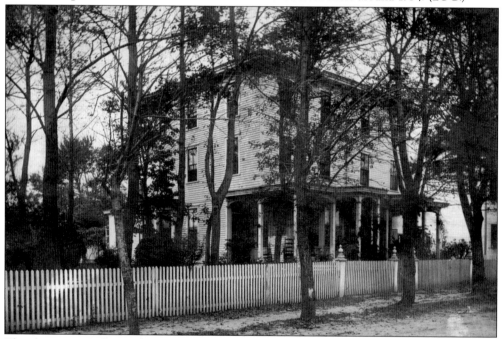

This three-story Italianate house still stands on Lafayette Street. It was built about 1870 for Joseph Leach, publisher and editor of the city's newspaper, the *Cape May Ocean Wave*, for a number of years. In that position, he greatly influenced the building of the railroad to Cape May City in 1869. Leach held many elected positions and served as a county freeholder for six years. (CMCHGS.)

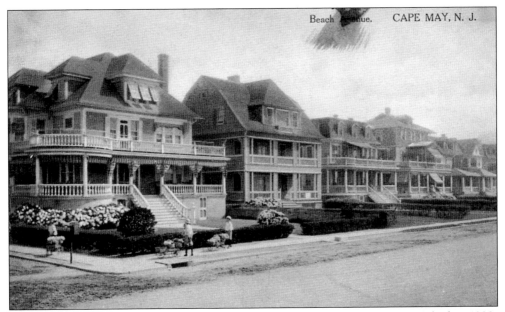

Vacant land on Beach Avenue above Jefferson Street was developed beginning in the late 1800s and early 1900s. Seen here about 1920 at the corner of Jefferson Street and Beach Avenue is a row of summer cottages, all of which still stand. They are built in the popular styles of the day, including Colonial Revival, Dutch Colonial Revival, and American Foursquare. Facing the Atlantic Ocean, all featured expansive front porches that capitalized on their waterfront views. (DP.)

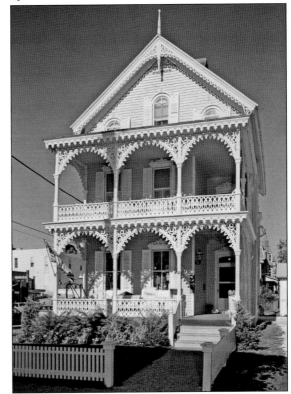

Known as "the Pink House" for its distinctive color, the Eldredge Johnson House was probably built about 1880. Originally on Congress Place, behind the Congress Hall hotel, it was moved in the late 1960s to its present location on Perry Street. Johnson, who purchased its original lot in a public auction in 1879, owned a shoe store in Cape May City. (LOC.)

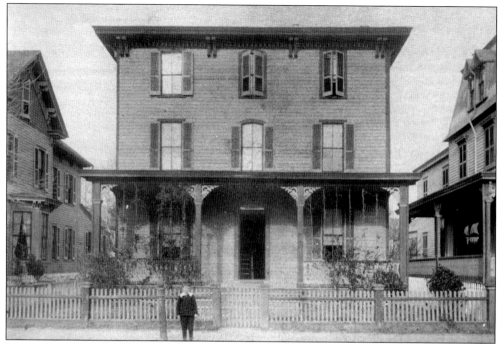

Located on Columbia Avenue, where it still stands, not far from Franklin Street, this three-story cottage was probably built in the 1870s. Its Italianate style was popular for houses at the time. As seen here around 1900, the residence has many of the style's characteristics, including a flat roof supported with a bracketed cornice and a gingerbread-trimmed front porch. (CMCHGS.)

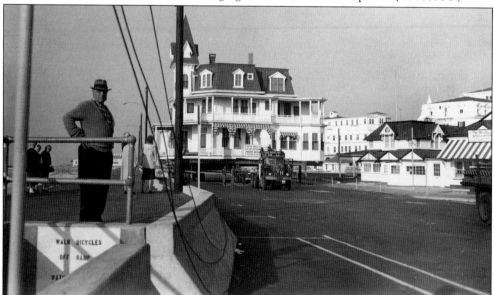

Moving houses, even massive structures like part of the Weightman Cottage seen here in 1963, was more common than one might think. Houses made of wood were those most prone to be moved. The earliest reference to a house being moved in Cape May County is dated 1769. In 1819, local carpenter Isaac Smith used 24 horses, 12 men, and 4 wagons to move a house in Lower Township. (CMCHGS.)

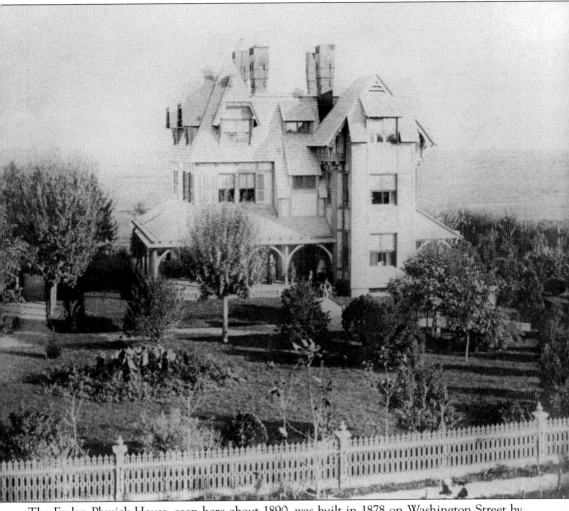

The Emlen Physick House, seen here about 1890, was built in 1878 on Washington Street by Mrs. Frances M. Physick Ralston and her son, Emlen Physick Jr. Philadelphians, they moved to Cape May in the early 1870s. Local newspapers called the Stick-style house a "handsome villa." Its design is attributed to Philadelphia architect Frank Furness. Physick, trained as a physician, never practiced, becoming instead a successful real estate entrepreneur. Active in the community, he helped found the Cape May Golf Club and saved a failing bank from bankruptcy, using his own funds to pay depositors. The house was lived in by Physick descendants until 1935. After decades of neglect, the mansion was restored in the 1970s by the Mid-Atlantic Center for the Arts and Humanities, which operates the site as a historic house museum. (Mid-Atlantic Center for the Arts and Humanities.)

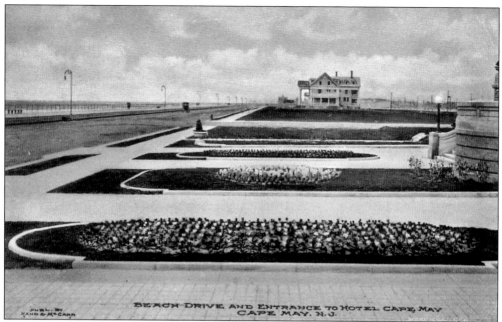

In 1906, Peter Shields, president of the Cape May Real Estate Company, commissioned Lloyd Titus, a Philadelphia architect, to design the stately Colonial Revival house seen below. Still standing on Beach Avenue, not far from the site of the now-demolished Hotel Cape May, the house and its grandeur reflected Shields's vision for the ambitious East Cape May development, which he hoped would attract not only summer visitors, but land purchasers as well. Shields first gained prominence as a real estate developer in Pittsburgh and was one of several capitalists from that city who banded together to improve vacant land on the east side of Cape May in 1903. Less successful than anticipated, the company folded in 1915. The house later served as the headquarters of the Cape May Tuna Club in the 1940s. (Both, DP.)

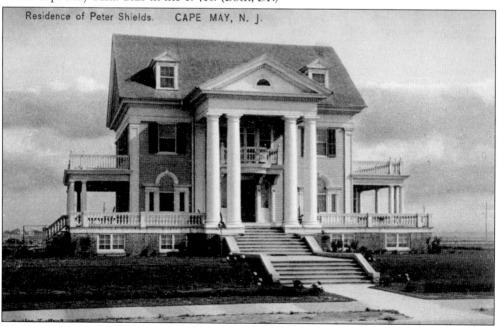

Four

ENTERTAINMENT

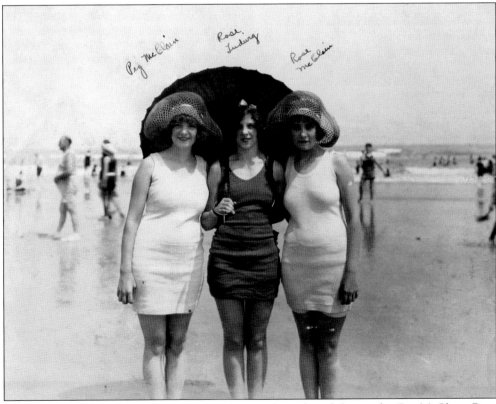

Photographed near the Cape May surf in the 1920s are, from left to right, Peg McClain, Rose Ludwig, and Rose McClain. Their bathing costumes were typical of the period, consisting of a one-piece garment with a long top that covered shorts. Usually made of a wool knit, but sometimes of cotton, the suits reflected the growing trend of baring more skin at the beach. (CMCHGS.)

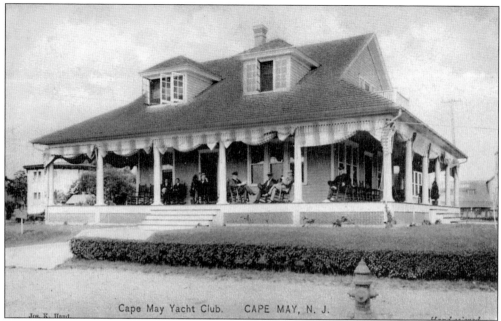

Cape May Yacht Club. CAPE MAY, N. J.

Incorporated in 1904, the Cape May Yacht Club was located near Schellenger's Landing at the head of Washington Street. Surrounded by a broad porch on all four sides, the building contained a restaurant and sleeping quarters used by its members. The club, which no longer stands, sponsored regattas, musicals, and banquets. In the left background of this c. 1915 photograph is the Octagon House on Lafayette Street. (DP.)

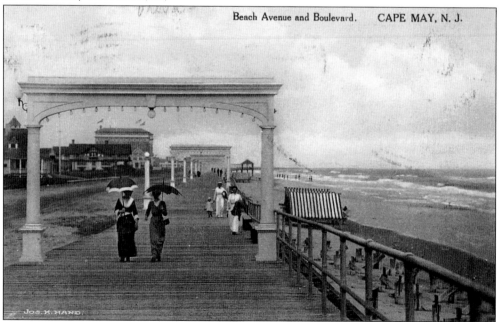

Beach Avenue and Boulevard. CAPE MAY, N. J.

By 1868, Cape May offered a "wide plank walk" more than 1,000 feet long for use by "all who do not desire to walk on the sand." This was the first seaside resort to build what later became known as a boardwalk. As seen in this postcard, Cape May's boardwalk in the early 1900s featured a series of columned arches enhanced with lights for nighttime strolling. (DP.)

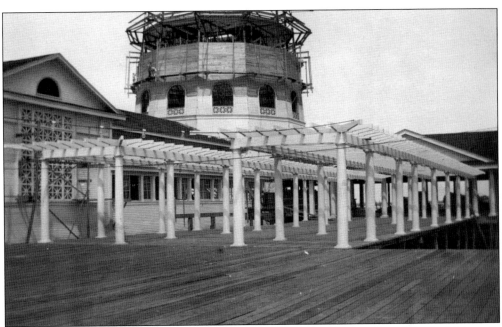

The Fun Factory was erected around 1913 at Sewell's Point in East Cape May by Nelson Z. Graves. A Philadelphia manufacturer and longtime cottager, Graves had taken over the failing East Cape May Company and built this amusement park to attract summer visitors. It featured a carousel, a fun house, a skating rink, a revolving barrel, and a large slide that people rode while sitting on a piece of burlap. The top of the park's tower had a viewing platform 85 feet above the water. In 1917, the Fun Factory was adapted for military use when US Navy Section Base Nine was established on several hundred acres here. (Both, DP.)

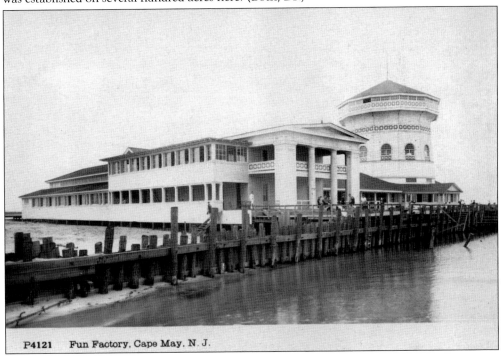

P4121 Fun Factory, Cape May, N. J.

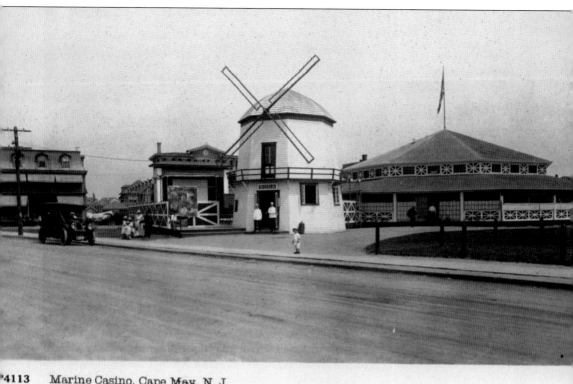

4113 Marine Casino, Cape May. N. J.

The Marine Casino, which no longer stands, was built in 1913 on the former Marine Villa lot at the corner of Howard Street and Beach Avenue. As seen in this c. 1914 postcard, an octagonal casino with a dance floor and merry-go-round dominated the amusement center. A soda fountain was located in the windmill, which later became known as the "Red Mill." An open-air pavilion with a large outdoor screen for movies is seen to the left of the windmill. The sign out front advertises the recently released two-reel movie *Alone in the Jungle*, which featured a lion chasing silent-screen star Bessie Eyton through the jungle, onto a cliff, and across a river until it is shot just as she is caught. Dances were often held by subscription, with cottagers paying a set fee per week to reserve the dance floor for themselves and their guests. Up to 400 dancers could be accommodated. (DP.)

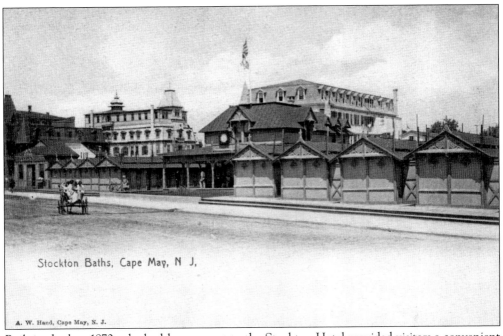

Stockton Baths, Cape May, N J,

A. W. Hand, Cape May, N. J.

Built in the late 1870s, the bathhouses next to the Stockton Hotel provided visitors a convenient place to change into, and out of, their bathing suits. Located on Beach Avenue between Ocean and Gurney Streets, long rows of one-story bathhouses flanked a two-story pavilion that was a daily meeting place for daintily dressed women and men in flannels. Clotheslines, seen in the postcard below, were placed on top of the heavy tin roofs, providing a handy place to dry the heavy, knit wool bathing suits. For years, the bathhouses were painted yellow with brown trim and sported red tin roofs. At the far end of the bathhouses was a small photography gallery. Most of the bathhouses were demolished in the 1960s to provide a parking lot for the Colonial Hotel. (Both, DP.)

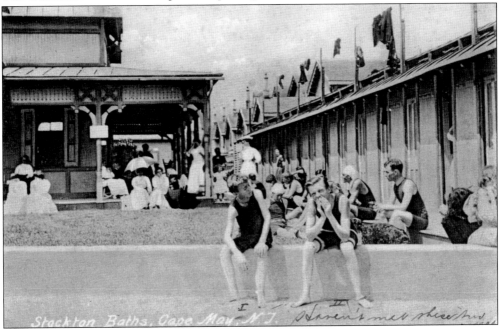

Stockton Baths, Cape May, N.J.

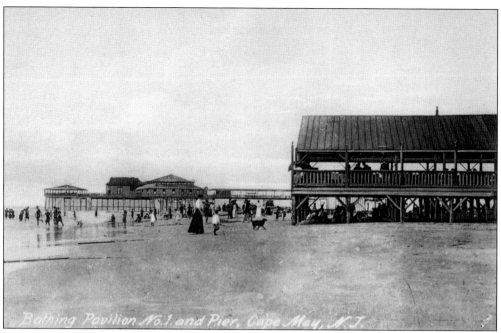

Bathing Pavilion No. 1 and Pier, Cape May, N. J.

The three public bathing pavilions built on the Cape May beach in the early 1900s offered two levels of shade and oceanfront breezes for those seeking relief from the hot sun. The front of each had a reading room. Visible in the distance is the Iron Pier, which featured its own bathing pavilion. The pier was built in 1884 and designed by the Phoenix Iron Company. (DP.)

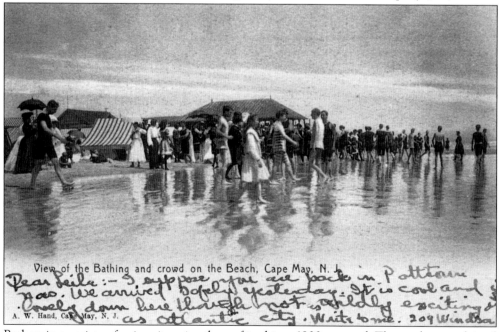

View of the Bathing and crowd on the Beach, Cape May, N. J.

A. W. Hand, Cape May, N. J.

Bathers in a variety of swimsuits enjoy the surf in this c. 1900 postcard. The sender complained that Cape May was not "as wildly exciting as Atlantic City," which at the time offered five entertainment piers, a roller coaster, several movie theaters, two merry-go-rounds, and rolling chairs that could be hired for a tour of the boardwalk. (DP.)

54

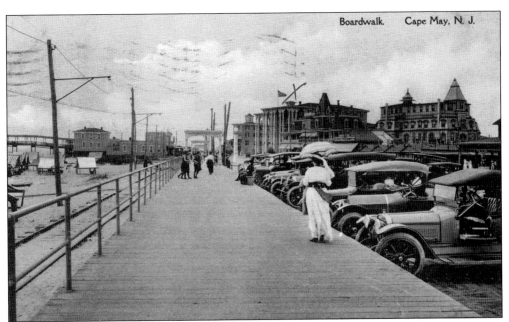

For this c. 1920 postcard, the photograph was taken at the foot of Gurney Street, opposite the Stockton Baths. The view looks west down the boardwalk. Seen in the distance and marked with a handwritten X is the Lafayette Hotel, with its distinctive paired columns. At right is the four-story Star Villa, built in 1885, facing Ocean Street. In 1967, it was moved to East Cape May, where it still stands. (DP.)

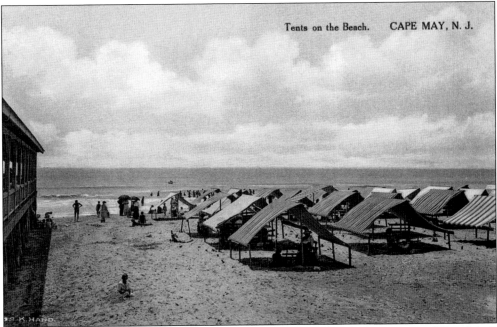

Tents on the Beach. CAPE MAY, N. J.

A small city of striped, canvas-covered tents offered much-needed shade near one of Cape May's beach pavilions. Each tent, held by stakes to prevent it from blowing away in a sudden gust, featured a bench or two that faced the ocean. Ladies standing near the water carry umbrellas as protection from the sun. (DP.)

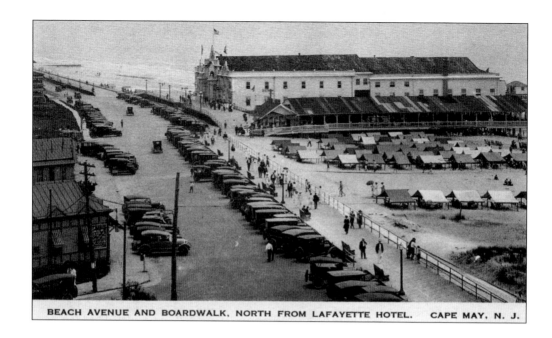

BEACH AVENUE AND BOARDWALK, NORTH FROM LAFAYETTE HOTEL. CAPE MAY, N. J.

Completed in time for the 1917 season, Convention Hall was built on the beach at the terminus of Stockton Place, opposite the site of the Stockton Hotel, which had been torn down in 1910. In the above postcard, it is seen at its oceanfront location just beyond Bathing Pavilion No. 1. Erected on piers at a cost of $70,000, the hall had 250 feet of frontage on Beach Avenue and extended several hundred feet over the ocean. The building, owned by the city, featured a movie theater, an auditorium for band concerts, several stores, and a billiards room. In the back was a long fishing pier over deep water that quickly became a favorite with local anglers. It no longer stands. (Above, DP; below, CMCHGS.)

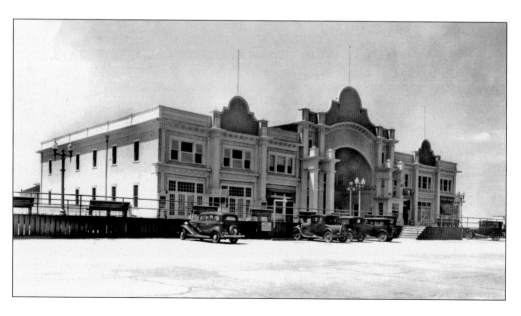

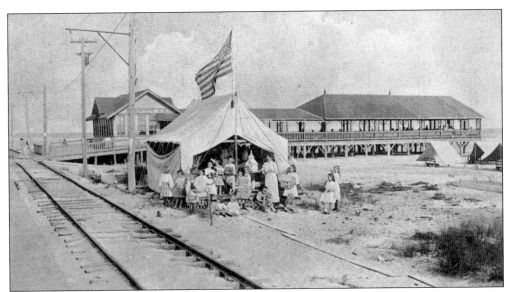

Several unidentified children pose in front of a light-colored tent pitched just south of one of the bathing pavilions in this c. 1900 postcard. The tracks at left served a train that carried visitors from Steamboat Landing at Cape May Point to Cape May and then to a popular but short-lived restaurant called the Inlet House on Sewell's Point. (DP.)

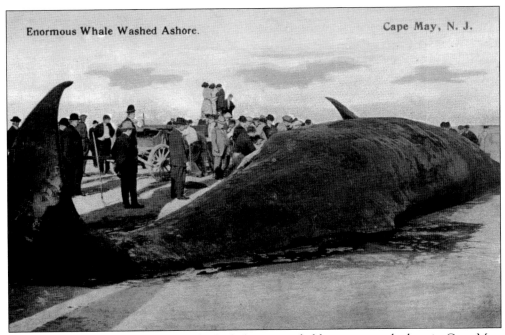

Enormous Whale Washed Ashore. Cape May, N. J.

This c. 1910 postcard depicts a beached whale surrounded by curious onlookers in Cape May. Whales did, in fact, wash up on shore here, providing somewhat morbid entertainment. But this photograph appeared on postcards issued with several other resort names as the location, including Ocean City, Stone Harbor, Atlantic City, Cape Cod, and even Florida. (DP.)

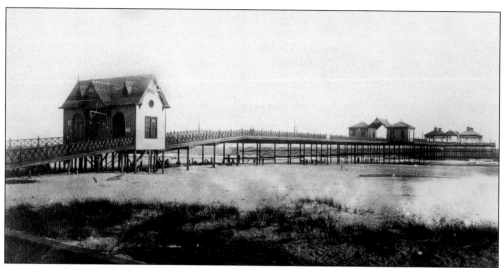

The 1,000-foot-long Iron Pier, constructed for Victor Denizot in 1884 at the foot of Decatur Street, quickly became the most popular resort attraction in Cape May. It opened shortly after Independence Day, despite being only half complete; its grand opening was held at the end of August. The pier, accessible only after one paid an admission fee, featured two pavilions and a 30-foot-wide walkway accented with lights at night. The larger of the two pavilions was used for concerts and dancing. In 1887, a deck was added under the music pavilion, where fishermen reeled in sharks, blue fish, and rock fish. The entrance, destroyed by fire in 1907, was rebuilt and featured several shops. The pier and its buildings were demolished in the 20th century. (Both, CMCHGS.)

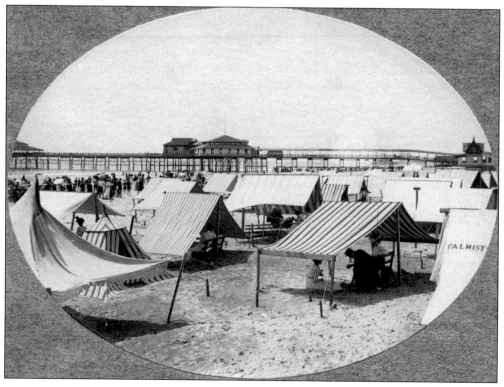

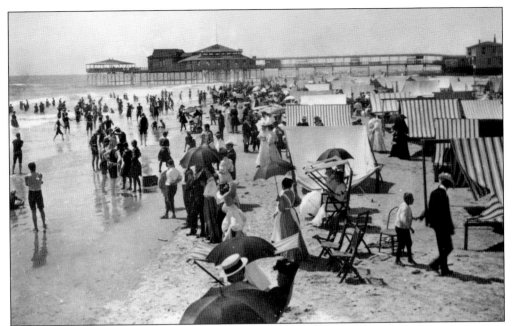

This c. 1900 photograph of a beach scene shows an expanded Iron Pier in the background. While many chose to wear street clothes while on the beach, others sported bathing costumes that were popular at the time. Women donned wool dresses that stopped at the knees, their lower legs covered with stockings to retain modesty. Men wore two-piece suits of knit shorts and tank tops. (CMCGHS.)

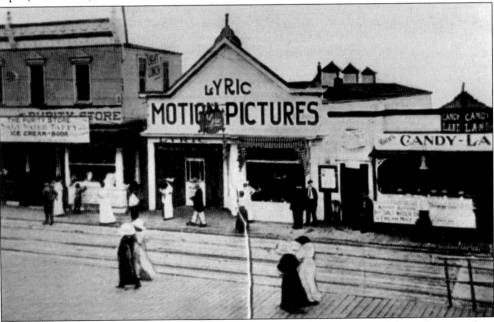

Next to the Iron Pier entrance was the Lyric motion picture theater, one of three showing silent movies to Cape May's visitors in the 1920s. The others were the Palace on Washington Avenue and the city-owned Cox Theatre in Convention Hall. Roth's Candy Land shop next door sold saltwater taffy, which originated in Atlantic City. (CMCHGS.)

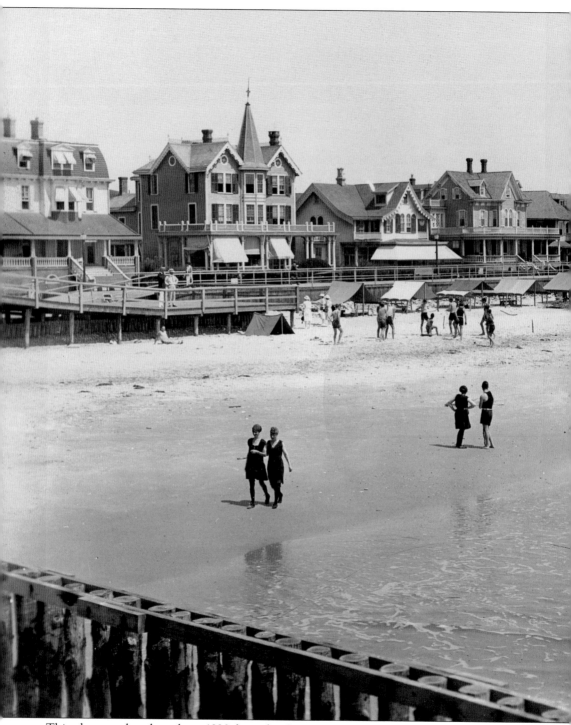

This photograph, taken about 1920 from the Convention Hall pier, gives a panoramic view of the fashionable cottages that lined Beach Avenue between Howard and Queen Streets. Built between the 1870s and the early 20th century, these oceanfront houses were designed by well-known architects for prominent families, most of them from Philadelphia. The tall building in

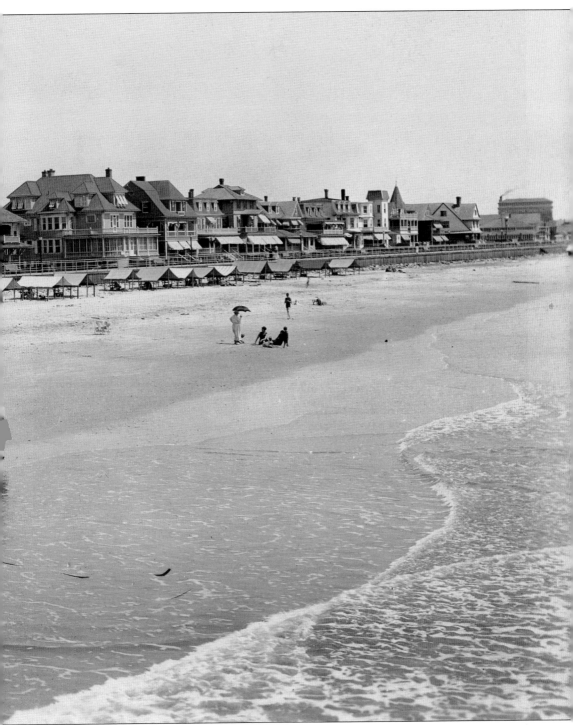

the distance on the far right is the Hotel Cape May, completed in 1908. Not far from the hotel is a one-story, octagonal-shaped building that housed a theater and a carousel. Several of the structures, including the hotel, have been demolished, making way for modern motels, single-family houses, and a miniature-golf course. (CMCHGS.)

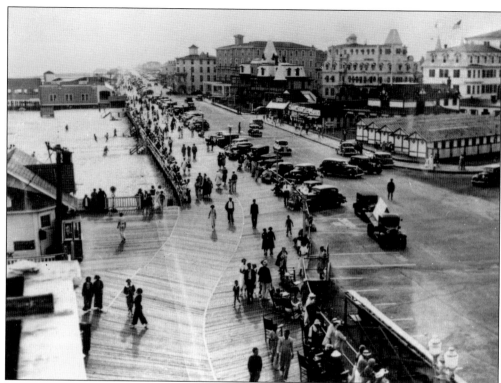

Taken from the roof of Convention Hall, this c. 1920 photograph looking west down Beach Avenue shows the long rows of one-story Stockton bathhouses at right. In the distance at left is Cox's Pier, built on piles over the beach and ocean. It contained stores and an open-air theater. (CMCHGS.)

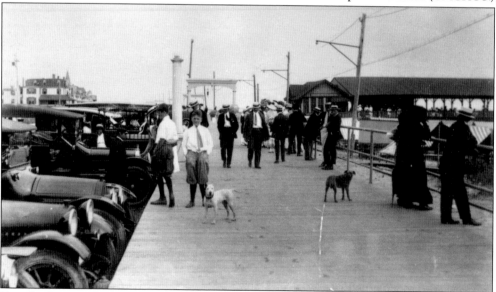

Dogs freely roam the boardwalk in this early-20th-century photograph. Public bathing pavilion No. 1 at the foot of Gurney Street is on the right. In the distance at left is the Henry Tatum House, a cottage built in 1872–1873 near the corner of Howard Street. It was later a guesthouse called the Marine Apartments. It still stands. (CMCHGS.)

Taken about 1910, this photograph shows the entrance to the Iron Pier on the right, rebuilt after a fire in 1907. Opposite the pier are the tall pillars marking the mammoth Stockton Hotel, which was torn down in 1910. The three girls seem oblivious to the young man, who appears to be asking for directions. (CMCHGS.)

John McCreary built a towered villa, which still stands, at the corner of Columbia Avenue and Gurney Street in 1870. The side yard, seen in this c. 1890 stereopticon view, hosted croquet games held in front of an elaborate garden house. Croquet began in the British Isles in the mid-19th century and quickly spread to other English-speaking countries. It was played in Cape May as early as the 1860s. (LOC.)

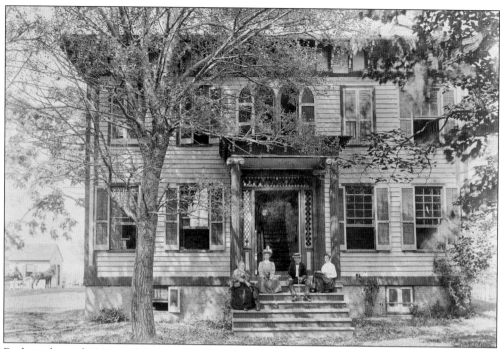

Built in the mid-1800s and designed by Sidney & Neff architects of Philadelphia, the three-story bracketed Italianate Villa on Lafayette Street (above) was occupied by Thomas Wales, a farmer, in the late 19th century. In 1897, local cottager Dr. Emlen Physick helped organize the Cape May Golf Club, and its 80-plus members, most of them wealthy cottagers from Philadelphia, created a nine-hole golf course on Wales's 40-acre farm. His house was converted into the clubhouse (below). It was the only golf course in the city, and its spacious grounds were also used for lawn fetes and informal dances. The building, which still stands, has lost its original cupola, chimneys, and porches over the years. The club failed in the 1940s, and the house was bought by the Fraternal Order of Moose, which vacated it in 1978. (Above, CMCHGS; below, DP.)

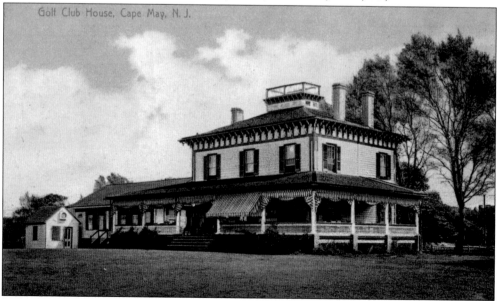

Golf Club House, Cape May, N. J.

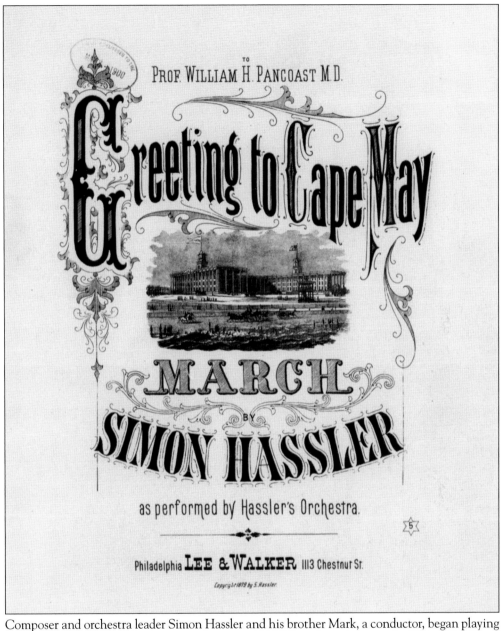

Composer and orchestra leader Simon Hassler and his brother Mark, a conductor, began playing in Cape May with their three-piece orchestra in 1849. Their first job was at the White Hall Hotel on Lafayette Street, where, in exchange for room and board, they performed for the hotel guests. They later had engagements at such prestigious hotels as Congress Hall, the Columbia, and the Sea Breeze Excursion House. While at the Stockton Hotel, the Hasslers' orchestra played "Hail to the Chief" during Pres. Chester A. Arthur's visit in 1883. A year earlier, Simon and two other conductors led a 125-man orchestra during the Grand Music Festival held at Cape May, which was billed as the "greatest event of the kind ever held at a watering place." Little is known about the march he composed in 1879 about Cape May, but one historian claims it was arranged by Philip Sousa, who often played violin with Simon's orchestra. Congress Hall is featured prominently on the sheet music's cover. (LOC.)

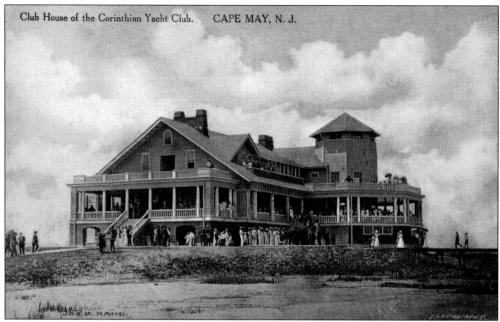

Club House of the Corinthian Yacht Club. CAPE MAY, N. J.

The Corinthian Yacht Club, an offshoot of the Cape May Yacht Club, erected its clubhouse at the end of Yale Avenue in 1913. The commodious clubhouse, which no longer stands, was impressive and featured several wraparound porches overlooking the newly created Cape May harbor. It was requisitioned by the US government for use as Section Base Nine headquarters in 1918. (DP.)

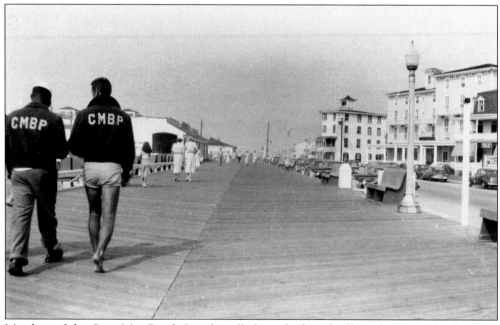

Members of the Cape May Beach Patrol stroll along the boardwalk in the 1950s. At the time, the city was entering a slow decline, losing visitors who preferred the modern motels and livelier boardwalk in nearby Wildwood. At right is the Lafayette Hotel, torn down in 1978. It is seen here remodeled, without its distinctive four-story columns. (CMCHGS.)

The present Cape May lighthouse, located in nearby Cape May Point, was built in 1859 after two earlier ones failed. Before the boardwalk was built, visitors would drive their carriages along two miles of hard-packed sand to reach the landmark. As early as the 1880s, lighthouse keepers allowed visitors to climb to the top for a stunning view of the bay and ocean. (LOC.)

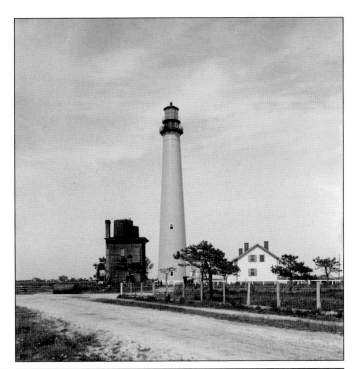

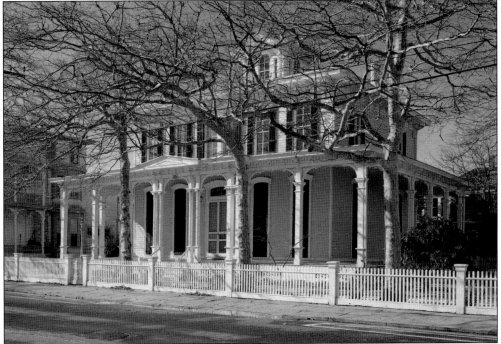

Jackson's Club House, which still stands, was built as a gentleman's gambling establishment in 1872 at the corner of Columbia Avenue and Stockton Place. The cupola-topped residence hosted games of chance until the 1880s, when it became a private home. By the mid-1900s, it was called the Victorian Mansion and offered guest rooms. In 1977, it became the Mainstay Inn, the city's first bed-and-breakfast. (LOC.)

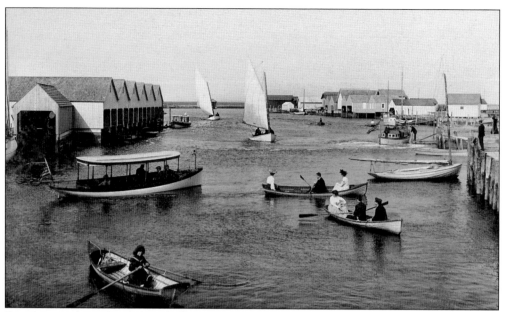

Seen here in the early 1900s, Schellenger's Landing at the head of Lafayette Street was a popular place for boating and fishing. The landing was sited on Cape Island Creek, which separated Cape May from the mainland, near the present-day Lobster House restaurant. It is named for the Schellenger family, who settled in this area in the 1800s. (CMCHGS.)

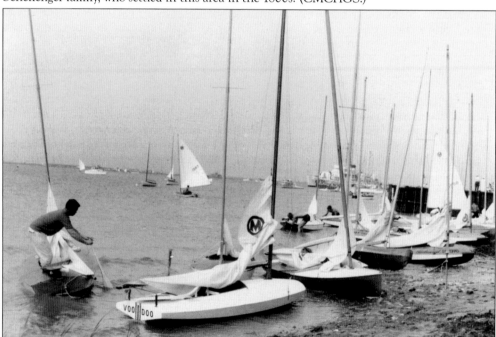

The national moth championship races were held in Cape May Harbor on August 1, 1959. The moth was an 11-foot-long racing sailboat designed in 1929 by Atlantic City resident Capt. Joel Van Sant as a small dingy that an amateur could build from simple blueprints and easy-to-follow plans. The first moth Van Sant built was named *Jumping Juniper*, for the Atlantic white cedar used in its construction. (CMCHGS.)

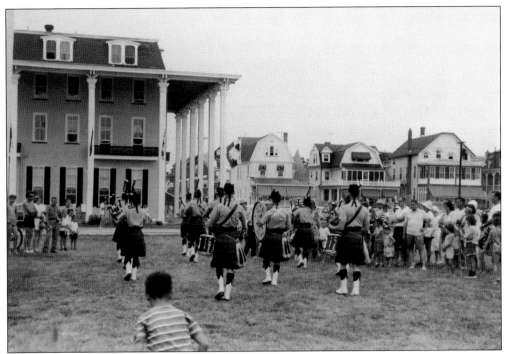

In the 1960s, the US Air Force Pipe Band from Washington, DC, played its bagpipes in front of Congress Hall. The occasion for the performance is not known. Originally part of the US Air Force Drum and Bugle Corps, this independent pipe band was organized in 1960. It disbanded sometime in the mid- to late 1960s. (CMCHGS.)

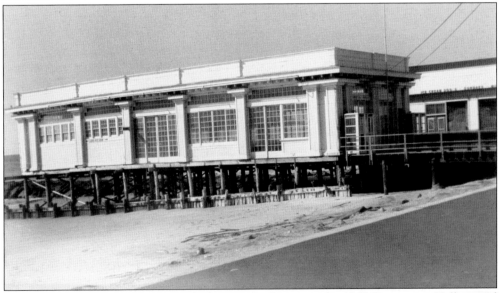

The 30-foot-by-90-foot solarium was built in 1993, adjacent to the 1965 Convention Hall erected on the site of the original convention hall. The new solarium closely replicated a c. 1912 building that stood next to the 1917 Convention Hall. The original solarium was destroyed by the March 1962 nor'easter. The 1993 solarium was demolished in 2010 to make way for a new convention center. (CMCHGS.)

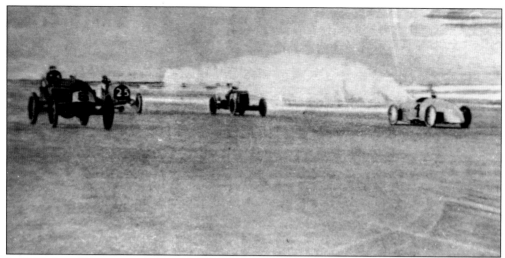

In 1905, Cape May mayor Thomas Millet helped to organize the Cape May Automobile Club. The group sponsored car races on the beach in front of the partially completed Hotel Cape May during the summer that year. About 10,000 people watched in late August as racing machines driven by Walter Christie, Louis Chevrolet, and Henry Ford sped along the hard, even beach between Madison Avenue and Sewell's Point. Hotels were filled to capacity, and special trains were added to accommodate overflow crowds for the two-day event, which offered an unprecedented $3,000 in prizes. The largest prize of $1,000 was reserved for the fastest mile clocked by a gasoline-powered car. Willie Campbell, driving a foreign-made Darracq, won four cups and set a new world record for a mile on the beach, clocking in at 38.4 seconds. (Both, CMCHGS.)

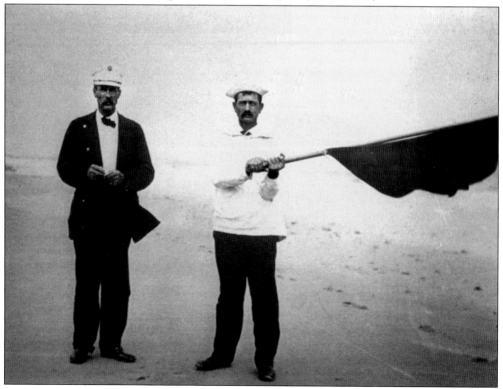

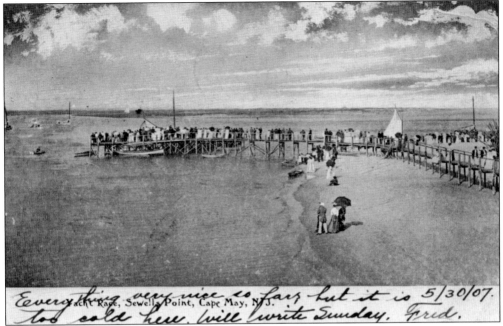

Everything very nice so far, but it is 5/30/07. too cold here. Will write Sunday. Fred.

Yacht Race, Sewell's Point, Cape May, N.J.

Sewell's Point, located at the easternmost edge of Cape May overlooking Cold Spring inlet, was a popular place for yacht races. The area was named for Civil War veteran and railroad director Gen. William J. Sewell, who developed the site in the 1860s. He established a horse trolley line from Cape May to the point, where he built a restaurant for summer vacationers. (DP.)

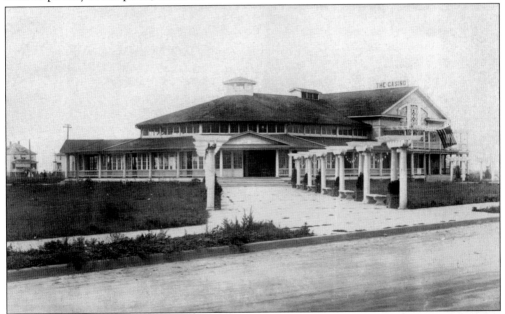

After Philadelphian Nelson Z. Graves took over the troubled East Cape May Development Company, he built a casino at the corner of Madison and Beach Avenues around 1912 in an attempt to rejuvenate the long-stalled project. A nationwide business crisis in 1913, however, bankrupted the company. In the 1920s, the casino (no longer standing) became a theater that offered live stage productions. (DP.)

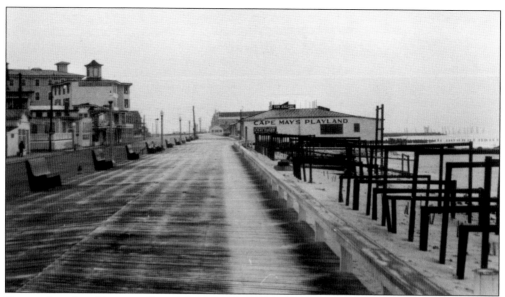

Deserted in the off-season, Cape May's boardwalk had changed only modestly by the mid-20th century. Several of its old oceanfront hotels had yet to be torn down, and the 1917 Convention Hall, seen in the distance, had managed to survive the 1944 hurricane. The Playland arcade, built on the site of a bathhouse, reflected the growing popularity of pinball and other electronic gaming machines. (CMCHGS.)

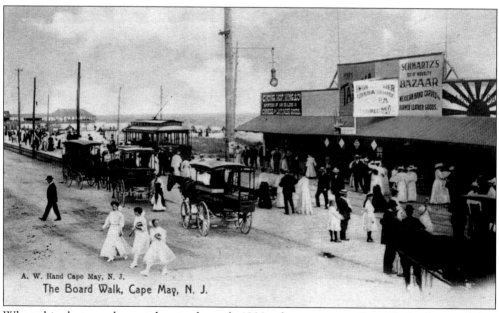

When this photograph was taken in the early 1900s, the entrance to Iron Pier had expanded to include several shops featuring imported Japanese, Chinese, and Mexican goods. The Iron Pier advertised Wednesday and Saturday matinees at its opera house, established there in the late 1880s. A fire in 1907 destroyed the stores seen here, but the opera house was untouched. (DP.)

Five

AFRICAN AMERICANS IN CAPE MAY

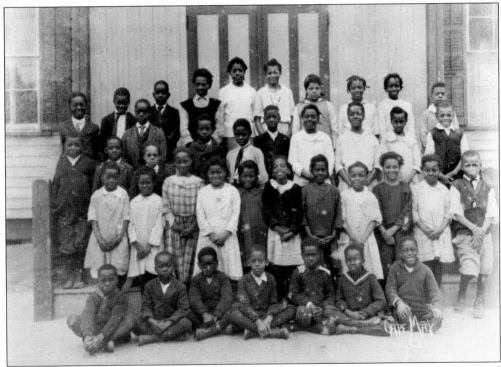

When the Lafayette Street School, located where the Acme grocery store stands today, opened for white students in 1901, the former elementary school was given to the African American students. Known as the Annex School, it was used until the new Franklin Street School was built in 1928. Here, unidentified students pose in front of the Annex School in 1923. Cape May's elementary schools were segregated until 1948. (CCA.)

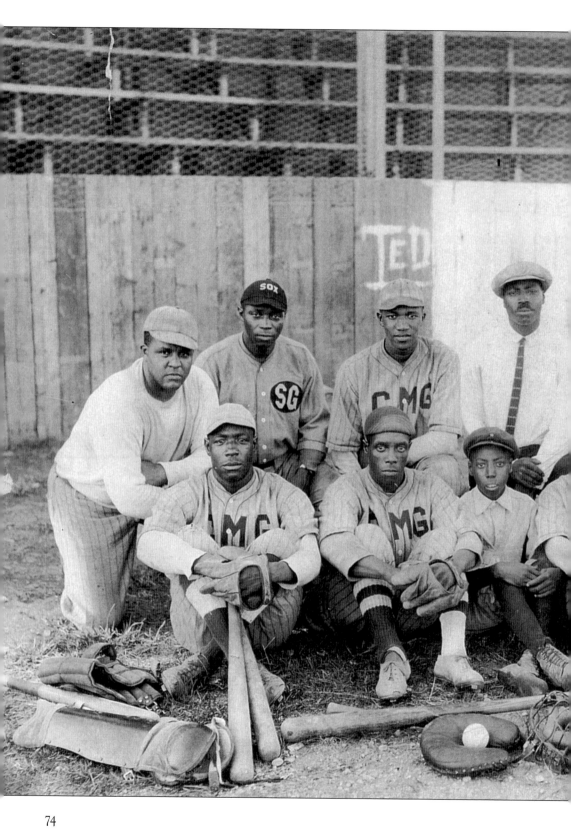

74

Cape May had an African American baseball team in the opening decades of the 20th century. Known as the Cape May Giants, it was the only African American team in the area. Local resident James L. Washington paid for their uniforms and equipment with his own money. They played every Monday and Thursday, their audience consisting mostly of white summer visitors. Mostly unpaid, they usually passed a hat among spectators and divided the proceeds among themselves after the game. Their ball field was located at the corner of Columbia and Madison Avenues. Shown here are, from left to right, (first row) unidentified, Douglas Hunt, James Washington Jr., Matthew Hunt, and unidentified; (second row) James Owens, James Washington Sr., William Poindexter, two unidentified, and ? Vance. (CCA.)

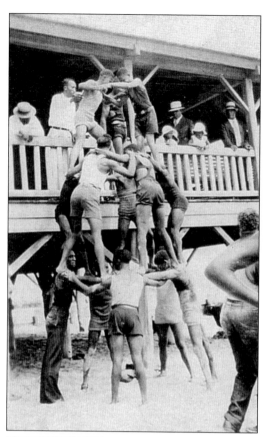

A daredevil group of African American and white men gather next to one of the bathing pavilions, nimbly forming a three-layer human pyramid. The beach at the foot of Grant Street was long known as the "Black Beach." It had African American lifeguards, and, even after desegregation, black families still congregated there. (CCA.)

Harry Richardson's New Cape May Hotel at the corner of Broad and Jackson Streets is the only one still standing of at least five hotels in the city owned by African Americans and operated for the African American tourist trade. A Philadelphia native, Richardson also owned an opera house in town that catered to an African American clientele. (CCA.)

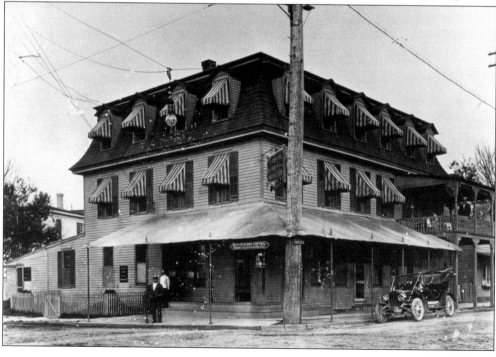

The Franklin Street Methodist Church was built in 1879 for a Baptist congregation that later moved to a new building in 1913 as the neighborhood became increasingly more African American. The church was bought by an African American Methodist congregation in 1916, which worshipped there until 2006, when the building was sold to a developer who converted it into several condominiums. (CCA.)

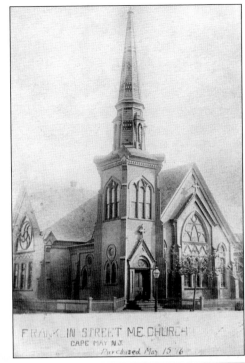

FRANKLIN STREET M.E. CHURCH
CAPE MAY N.J.
Purchased May 15 '16

A two-story opera house on Jackson Street, which no longer stands, also offered movies, boxing matches, and concerts to African American tourists. During World War II, it served as the African American USO. The crowd in this photograph has gathered in anticipation on April 23, 1944, to watch Paul Robeson, an internationally acclaimed African American singer and actor, dedicate the Jackson Street USO. (CCA.)

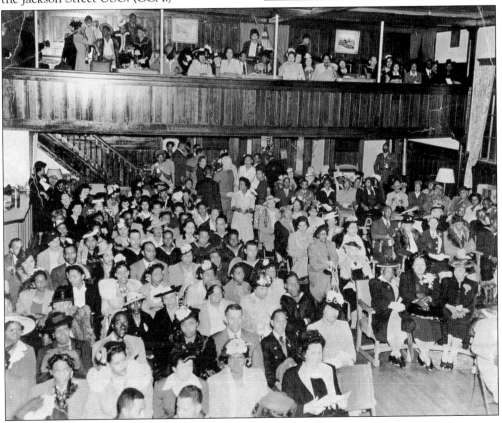

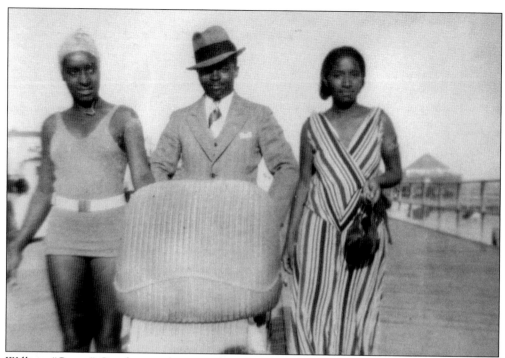

William "Capey" Capehart and two unidentified female companions stroll on the Cape May boardwalk in the 1930s. Although cordial relations existed between Cape May white and African American populations, segregation was still practiced in public places at the time. Blacks were kept away from white beach areas by the beach patrol, and they stayed in separate hotels. (CCA.)

The Macedonia Baptist Church was built in the early 1900s at the corner of Franklin and Lafayette Streets, where it still stands. It is one of the few all-concrete structures erected in the city. In the 1980s, its choir consisted of, from left to right, (first row) Edith Faison, Carolyn Faison, Pamela Boyce, and Lois Brown Smith; (second row) Lucy Cole, Melva Owens, Martha Wise Taylor, and Carolyn Davis. (CCA.)

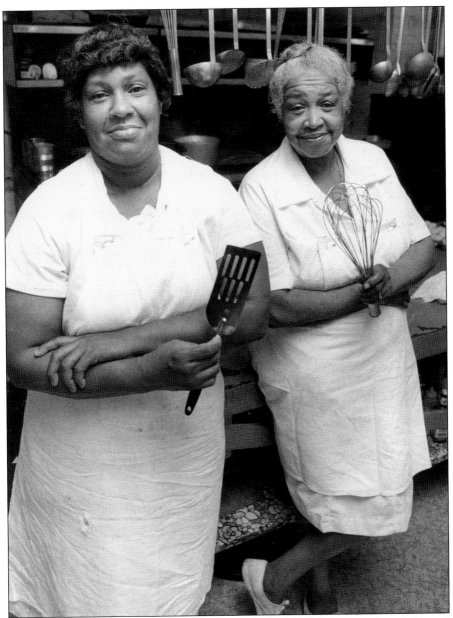

Dot Burton (left) and her mother, Helen Dickerson, pose in the kitchen of the Chalfonte Hotel around 1980. Helen began working at the Chalfonte when she was four, picking flowers for the dining room. She worked her way up to the position of head waitress in the dining room, and, by that time, two of her daughters, Dot and Lucille, helped her there. In 1945, she was offered a position in the hotel's kitchen. Eventually, all three became cooks, learning recipes from the older chefs who came from Philadelphia every summer to work in the Chalfonte's kitchen. Helen, who was employed at the hotel for 77 years (45 of them in the kitchen) until her death in 1990, became famous for her eggplant casserole, fried chicken, and crab cakes. She wrote a cookbook, *I Quit Stirrin' When the Tastin's Good*, and appeared on several television talk shows, preparing traditional Southern foods such as spoon bread and collards. Her daughters continued to work there, serving foods made from recipes their mother used for decades. (CCA.)

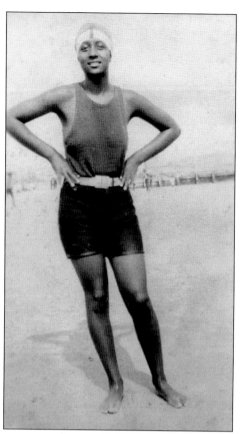

Cordelia Howard Bounds, born in 1913, graduated from Cape May High School (which, unlike the elementary school, was integrated) in 1929. She was the valedictorian, but, as an African American, she was denied the honor of giving the traditional speech. Bounds taught at Cape May's segregated Franklin Street School for six years and is that school's last surviving teacher. (CCA.)

Children pose with their homemade racecars on the Cape May boardwalk in the early 1900s. In 1905, Cape May began hosting automobile races on its hard, packed-sand beaches. Eventually, boys began making, and racing, their own cars. The two vehicles shown here, typical of those built without power engines, depended on gravity to generate speed. (CMCHGS.)

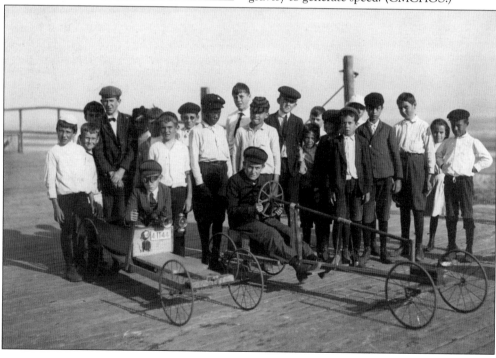

Six

FIRES, HURRICANES, AND OTHER DISASTERS

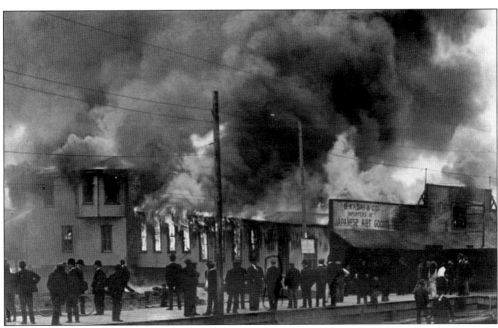

A pot of hot tar used to repair the roof over the stores marking the entrance to the Iron Pier started a fire there in May 1907. The flames quickly engulfed the buildings in front, but spared the opera house behind them. The blaze spread so rapidly that the fire department was of little use. The wife of the building's owner narrowly escaped the inferno. (DP.)

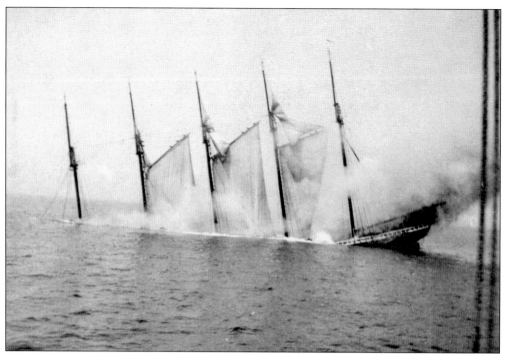

Located at the confluence of the Delaware Bay and the Atlantic Ocean, Cape May was the site of many shipping mishaps. Little is known about the incident that precipitated the fire that ultimately sank this five-masted schooner off the city's coast in 1918. The photograph was taken from a US Coast Guard cutter, so presumably, the captain and crew were saved. (CMCHGS.)

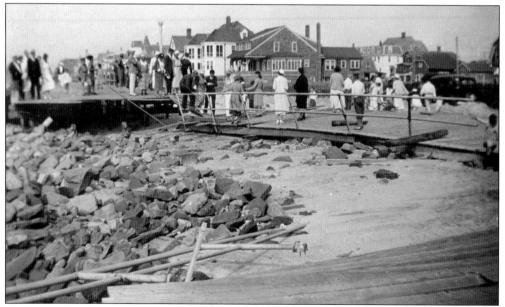

A fierce nor'easter roared up the New Jersey coast in April 1937, leaving devastation in its wake. In Cape May, streets were flooded, and the boardwalk was heavily damaged. This photograph, taken on the beachfront block between Madison Avenue and Queen Street, shows a large section of the boardwalk dislodged from its pilings. (CMCHGS.)

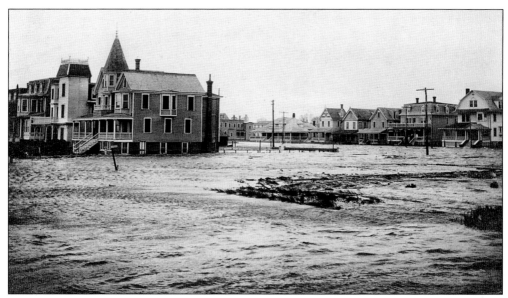

The March 1962 storm was one of the worst to hit Cape May in the 20th century. This photograph, taken on Beach Avenue near the corner of Queen Street, shows ocean water covering the streets and lapping against the foundations of houses on Beach Avenue (left) and on Stockton Avenue (right), which ran behind it. Most of these buildings still stand. (CMCHGS.)

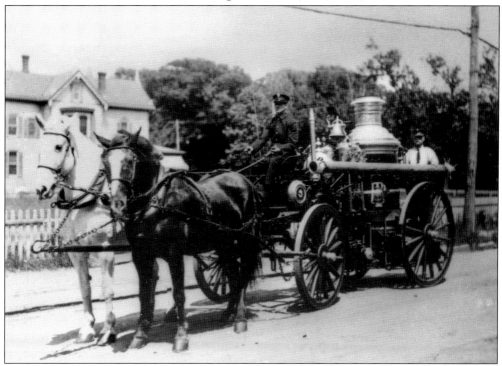

Around 1900, two horses pull a steam-driven pumper owned by the city's fire department. The metal cylinder behind the driver was actually a coal boiler that heated water to steam, creating power to drive the water pump. Some pumpers were capable of heating cold water to steam in three minutes and could generate a flow of 750 gallons per minute. (CMCHGS.)

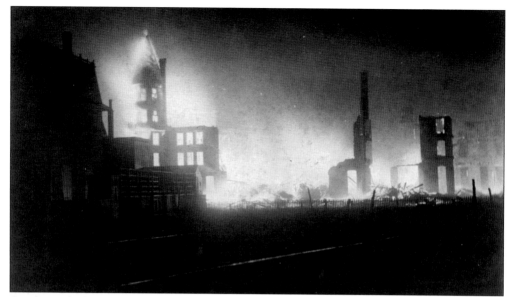

On the night of Tuesday, September 25, 1889, the New Columbia Hotel burned to the ground. Owned by James Mooney of Philadelphia, it was one of the city's largest hotels and stood on the beachfront block between Jackson and Perry Streets. A violent storm was raging at the time; east winds and heavy rainfall helped city firemen prevent the flames from traveling to most other buildings. However, Philip Koenig's Summer Garden (below), a beer garden adjoining the hotel, was destroyed. No lives were reported as lost; the hotel was largely vacant, the summer season having ended a few weeks earlier. The building and its contents were valued at $75,000. The first Columbia Hotel, which had burned down in the Great Fire of 1878, stood on Ocean Street. (Both, CMCHGS.)

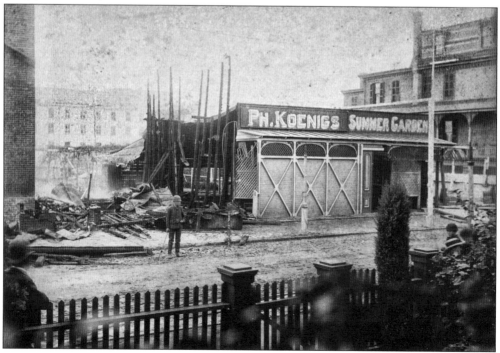

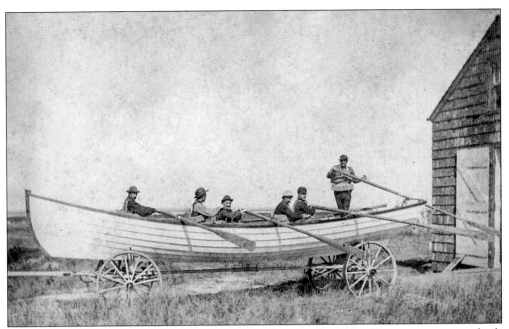

Beginning in the early 1800s, whale boats were used on the Cape May County coast to save both lives and merchandise from wrecks. Later, lifesaving stations fitted with surfboats, like this one, were established in New Jersey as part of the US Revenue Marine in 1848. Loaded onto a wagon, they were quickly dispatched to the beach when needed. (CMCHGS.)

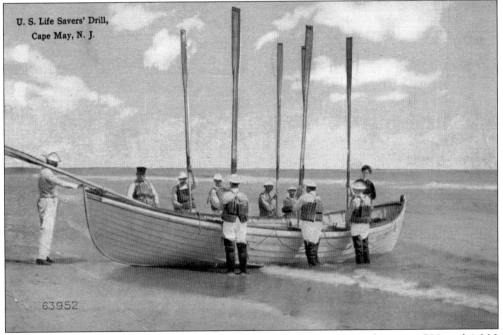

U. S. Life Savers' Drill, Cape May, N. J.

63952

By the early 1900s, self-righting and self-bailing surfboats weighing between 700 and 1,000 pounds were manned by full-time professionals, most of who worked year-round. In this c. 1905 postcard, surf men practice their skills with 12-to-18-foot-long oars as they prepare to launch into the ocean. (DP.)

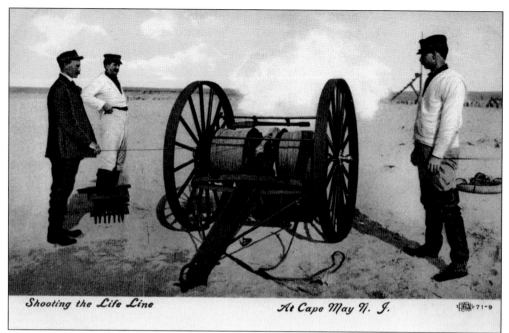

Shooting the Life Line *At Cape May N. J.* 71-9

A gunlike cannon called the Lyle gun was used to shoot a lifeline to crippled ships when seas were too rough for rescue by surfboats. As seen in this c. 1905 postcard, the Lyle gun was capable of projecting the line up to 600 yards. Once attached to the boat, the line was used by the stranded mariners to evacuate their vessel. (DP.)

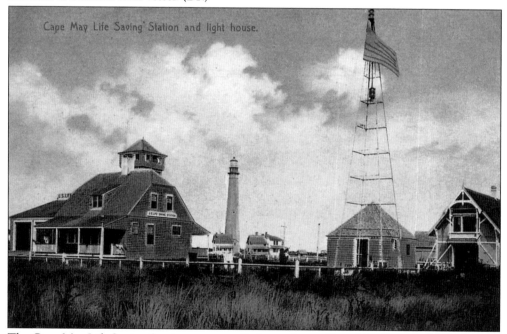

Cape May Life Saving Station and light house.

The Cape May Life Saving Station was actually located near Cape May Point, a few miles west of Cape May City. The station, built around 1890, is seen at left in this c. 1910 postcard, with the 1859 Cape May lighthouse behind it. This station replaced one built in 1876 for the Centennial Exhibition (far right). The lighthouse still stands, but neither station does. (DP.)

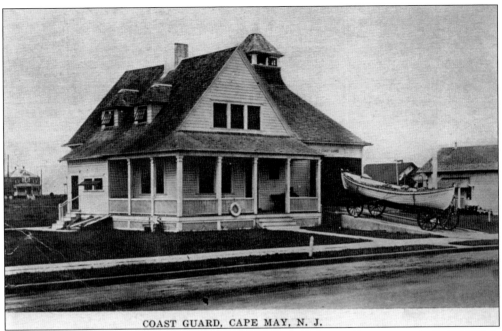

COAST GUARD, CAPE MAY, N. J.

Cape May City's first lifesaving station, known as the Cold Spring Station, was built in 1868. It was replaced with the building seen here in 1891 and is a classic example of the Bibb No. 2 style, named after its architect, Albert Bibb. Still standing on Beach Avenue, it serves today as the Cape May Kiwanis Clubhouse. (DP.)

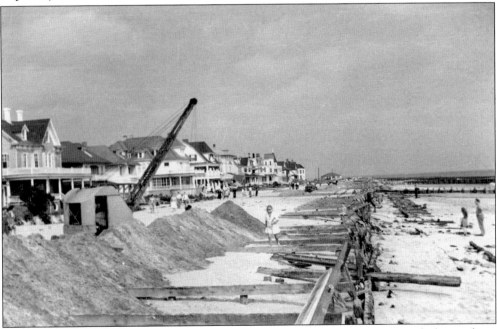

The September 14, 1944, hurricane was considered the worst that had ever struck the southern tip of New Jersey. Despite a wartime shortage of labor and materials, Cape May hastily rebuilt and was ready to greet vacationers for the 1945 season. Seen here is Beach Avenue, east of Convention Hall, where the boardwalk was heavily damaged. (CMCHGS.)

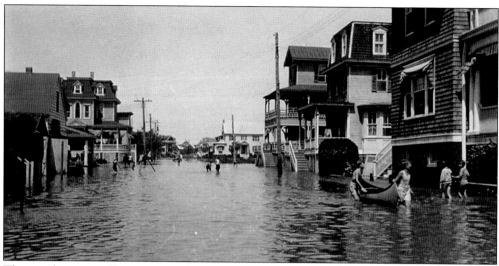

The weather was still warm enough after the September 1944 hurricane that children could paddle canoes and wade in the water-covered streets in their summer clothes. This view looks north up Jefferson Street from Stockton Avenue. Note the car in the distance, perhaps stranded in the middle of the roadway. (CMCHGS.)

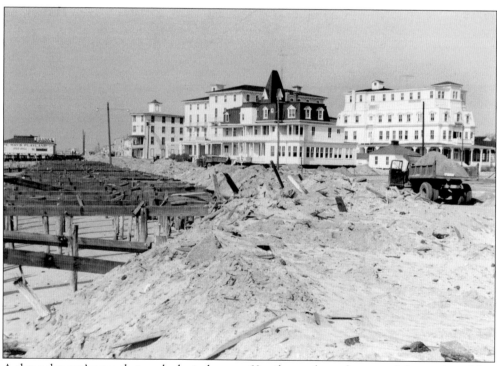

A three-day nor'easter that packed winds up to 60 miles per hour devastated the southern New Jersey coastline in March 1962. In Cape May, some beaches were entirely washed away, and most of the boardwalk and Beach Avenue were under water or blocked by sand and debris. This oceanfront photograph was taken at the foot of Gurney Street, looking west down Beach Avenue. (CMCHGS.)

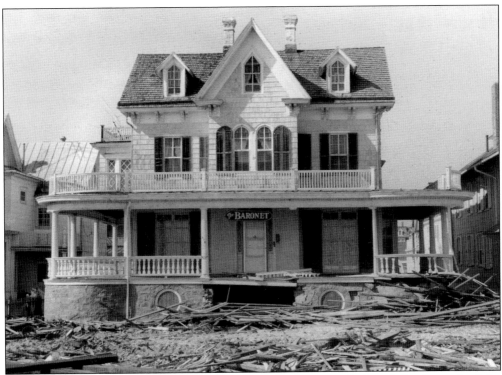

The Baronet Guest House, built in 1870 as a single-family cottage for Joseph Lewis, survived the 1962 storm despite its oceanfront location on Beach Avenue, where it still stands. In the three-county area of Cape May, Atlantic, and Ocean, it was estimated that 1,259 houses were destroyed and 2,527 had major damage. Cape May City's beach, among the hardest hit, received $2 million in federal aid for restoration. (CMCHGS.)

Convention Hall was damaged beyond repair in the 1962 storm and was eventually demolished. It was replaced in 1965 with a building that was half the original size and intended to be only temporary. The one-story solarium next to it, also heavily damaged, was rebuilt as well, but not until 1993. (CMCHGS.)

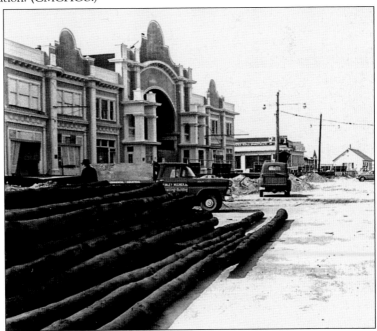

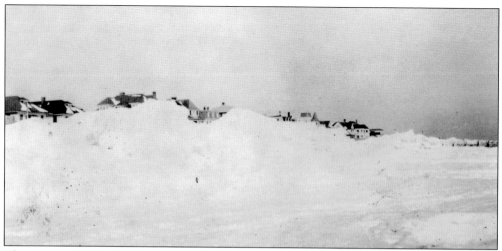

The winter of 1935–1936 was particularly harsh, with temperatures well below normal in the east. This photograph, taken on the beach at the foot of Howard Street and looking northeast, shows the high piles of snow that had collected there after a storm. While the ocean's somewhat warmer temperatures often protect Cape May from snow, nor'easter storms in the winter months can be devastating. (CMCHGS.)

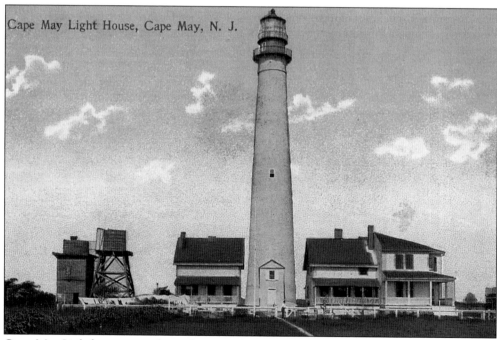

Cape May Light House, Cape May, N. J.

Cape May Lighthouse, seen here about 1915, was built in 1859 at the tip of the Cape May peninsula. It was the third to be erected here. The first was lost to encroachment by the sea, and the second was abandoned because of poor construction and because it was too short at 78 feet. The third lighthouse, 157 feet, 6 inches in height, opened for public tours in 1988 after an extensive restoration. (DP.)

Seven

TRANSPORTATION

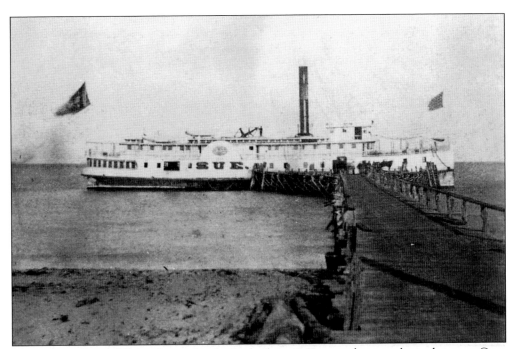

The steamer *Sue*, a 175-foot-long side-wheeler built in 1867, started seasonal trips between Cape May and Philadelphia in 1871. By 1874, the steamer made three round trips each week, leaving Cape May on Monday, Wednesday, and Friday and returning to Philadelphia the following day. In 1874, one-way fare, including carriage fare from Steamboat Landing to Cape May, was $2. By 1878, the steamer had berthed in Washington, DC. (DP.)

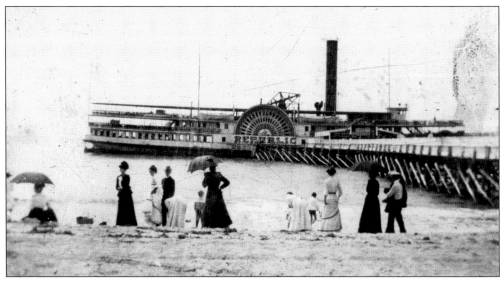

The steamboat *Republic*, seen above in 1902, made daily excursions from Philadelphia to Cape May, leaving the Race Street wharf at 7:30 a.m. and arriving in Cape May about 12:30 p.m. Launched in 1878, the steamer featured fully furnished saloons, 16 staterooms, and two private parlors on its three decks capable of handling 2,500 passengers. For the round-trip fare of $1, travelers received "luncheon and refreshments in abundance." She returned at 3:00 p.m., offering guests a fresh oyster supper, a full brass band, and orchestra music for dancing. Parlor entertainments were advertised as changing weekly. The *Republic* docked at Steamboat Landing (below), a wharf located at the western end of present-day Sunset Boulevard. By the 1880s, passengers were taken via railroad instead of wagon from the landing into Cape May, a distance of about three miles. (Both, CMCGHS.)

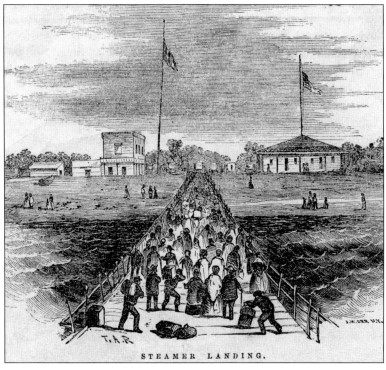

STEAMER LANDING.

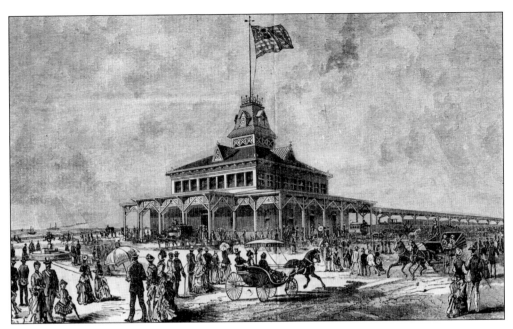

A railroad connecting Cape May and Philadelphia via Camden was completed in 1863, with the first train running on August 26. The three-and-one-half-hour ride was two hours shorter than the trip by boat and was considered a great improvement. The tracks entered the city from the north and terminated at Beach Avenue next to Grant Street. In 1876, the West Jersey Railroad built the passenger depot seen here at a cost of $20,000. Used only in the summer, it became known as the "summer station." The same year, the West Jersey advertised an express train to and from Philadelphia that took only two hours, a time made possible by the locomotive scooping water while in motion from a trough placed between the rails, thereby eliminating stops to replenish its water supply. The station was demolished in the 20th century. (Both, CMCHGS.)

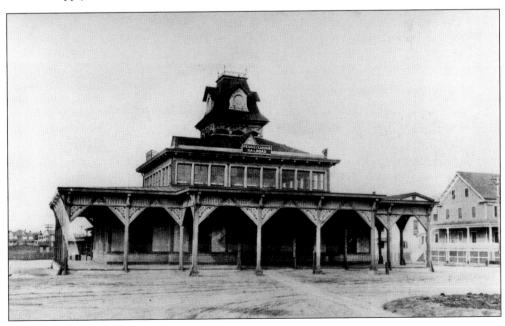

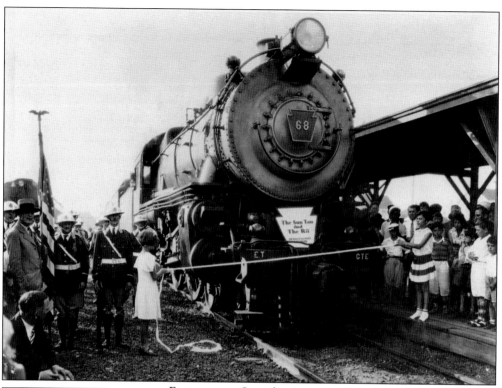

Festivities on Saturday, June 28, 1930, marked the arrival of the season's first direct service from Philadelphia to the 1876 summer station in Cape May. This train, known as the Sun Tan and the Rā, was jointly operated by the Pennsylvania Railroad and the West Jersey & Seashore Railroad. Looking on is Cape May's American Legion Color Guard. (HGM.)

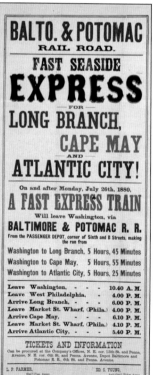

Printed in eye-catching red and blue, this 1880 broadside advertised an express train from Washington, DC, to three of New Jersey's oceanfront resorts: Atlantic City, Long Branch, and Cape May. The Baltimore & Potomac line took passengers to the West Jersey Railroad depot in Philadelphia, where they took a ferry to Camden, New Jersey. From there, they boarded a West Jersey line to any of the three destinations. (LOC.)

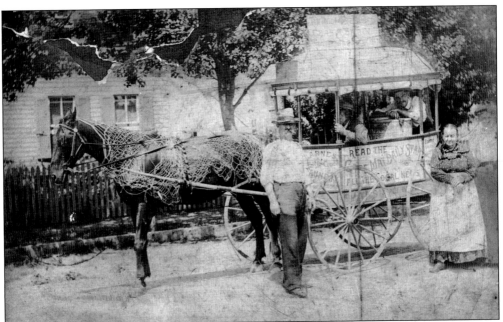

Among the earliest modes of transportation into Cape May was the horse-drawn wagon. Before the rail line to Cape May was built at Steamboat Landing in 1882, passengers disembarked their steamer and then hired a wagon to take them and their luggage to their hotel. The owner of this covered wagon cleverly used its sides to advertise tin-roof repair, laundry, saltwater baths, and the local newspaper. (CMCHGS.)

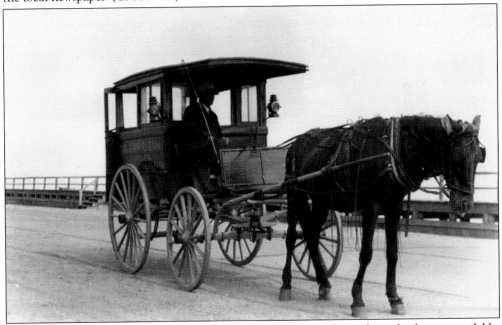

For those that preferred an enclosed taxi instead of public transit, horse-drawn hacks were available. This c. 1925 photograph depicts one such conveyance on Beach Avenue near the boardwalk. Transit advertising today is nothing new; the sign on the taxi's side reads, "J. S. Garrison, Jeweler." Jay Garrison was a jeweler, watchmaker, and optometrist on Washington Street. (HGM.)

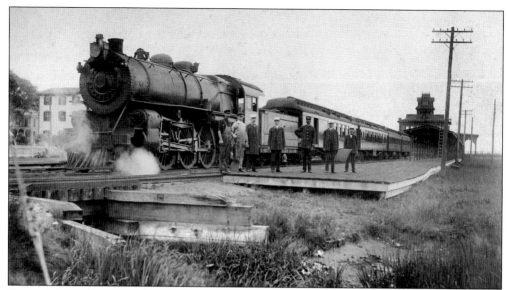

Engineers, conductors, and porters serving Pennsylvania Railroad locomotive No. 2125 stand on the platform at the Grant Street Station about 1912. By 1906, the weight of passenger trains had become so great that double-heading trains was necessary to maintain schedules. This resulted in the introduction of a new locomotive called the "Pacific type" (seen here). Its larger boiler created the additional pull necessary. The coal car had a 16-ton capacity. (CCA)

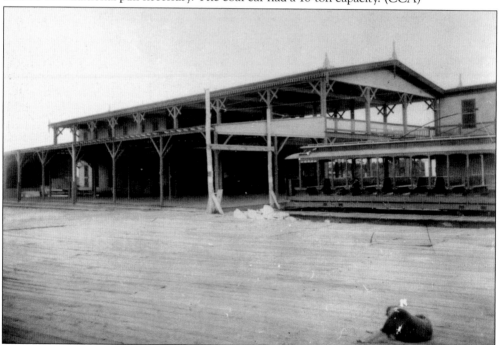

Ship passengers disembarking at Steamboat Landing outside of Cape May Point would find their way to the terminal pavilion of the Cape May, Delaware Bay & Sewell's Point Railroad, seen here about 1900. Located near the landing, the railway ran electric trolleys into Cape May City with connecting service to Sewell's Point, carrying both passengers and freight between these three destinations. (CMCHGS.)

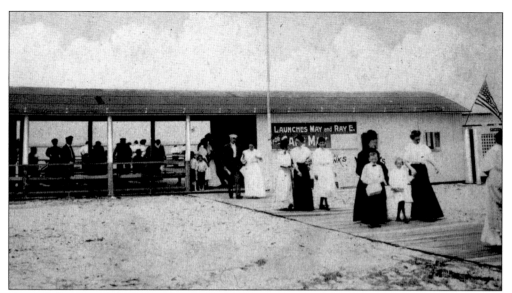

Around the turn of the last century, visitors could take a boat from Cape May to Sewell's Point, located several miles to the east at Cold Spring Harbor. The site was popular with anglers and with sailors who raced in regattas held there. The Inlet House restaurant served customers during the season. In 1912, an amusement center known as the Fun Factory was built here. (David and Teresa Williams.)

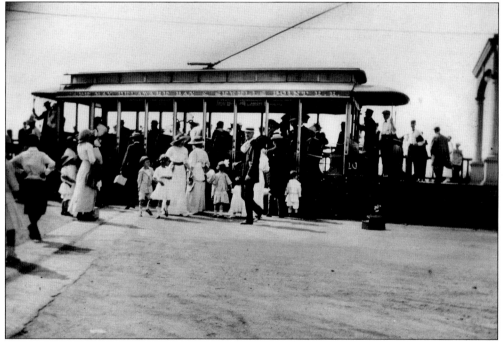

The Cape May, Delaware Bay & Sewell's Point Railroad combined two local rail lines in 1893 and provided continuous service from Steamboat Landing through Cape May Point, into Cape May, and then on to Sewell's Point, a total distance of about seven miles. The line used a combination of horse-drawn trolleys and steam locomotives; by the early 1900s, the trolley line had been electrified. (CMCHGS.)

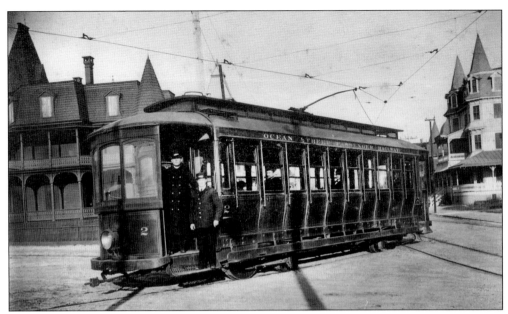

The Ocean Street Passenger Railway Company, seen here about 1910, was a two-car line that ran through the streets of Cape May and provided service to Schellinger's Landing at the head of Washington and Lafayette Streets. Incorporated in 1901, the line also used the tracks of the Cape May, Delaware Bay & Sewell's Point Railroad, providing service to Sewell's Point and Cape May Point. (DP.)

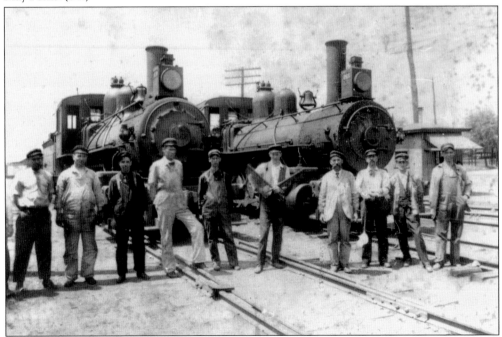

Railroad crew members pose in front of two steam locomotives in the early 1900s. Beginning in 1894, there were two competing rail lines into Cape May. In several places along the routes, the tracks ran parallel, and if two trains were running within eyesight of each other, the engineers often raced to see who would get to Cape May first. (CMCHGS.)

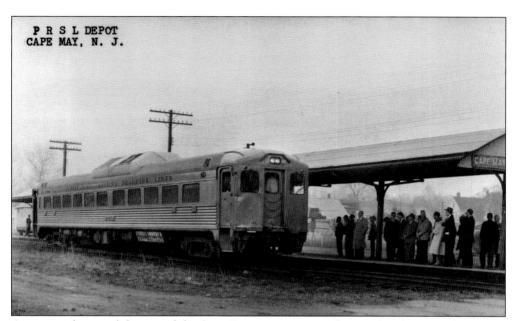

PRSL DEPOT
CAPE MAY, N. J.

As increased automobile use and the Great Depression cut into their profits, the Pennsylvania and Reading railroads merged their southern New Jersey lines in 1933 into one company, the Pennsylvania Reading Seashore Lines. Ridership continued to decline, and the number of runs was reduced accordingly. The last passenger train into Cape May County ran in October 1983. (DP.)

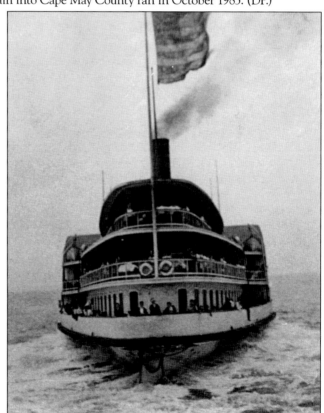

Ferry service between Lewes, Delaware, and Cape May—a distance of 12 miles—operated briefly beginning in 1900. New piers were constructed at both places for the steamer *Caroline*, and 30,000 passengers were transported the first season. In Lewes, the ferry connected with the Queen Ann's Railroad from Baltimore, greatly lessening the travel time to Cape May for those travelers. Round-trip fare was 50¢. (CMCHGS.)

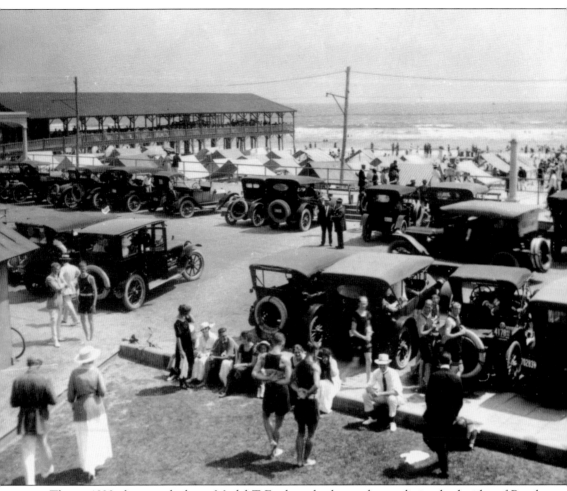

This c. 1920 photograph shows Model T Fords and other early cars lining both sides of Beach Avenue in front of the Stockton Baths. Cape May City was quick to embrace the automobile, sponsoring races on the beach and "roadibility" runs from Philadelphia for nonprofessional drivers. However, few realized the enormous impact car travel would have on the resort as the century progressed. The city's narrow streets were not designed to accommodate horseless carriages, and its old-fashioned hotels had been built before parking lots were a necessity. City hoteliers realized by the mid-1900s that, in order to survive, they had to provide parking, doing so by tearing down antiquated bathhouses for the ground on which they stood, or by paving part of their hotel's expansive front lawn. Beginning in the 1950s, motels were built that specifically catered to tourists arriving by car, offering them at-the-door parking. Several oceanfront houses were moved, and their lots were converted for parking. (CMCHGS.)

Eight

PEOPLE OF CAPE MAY

Prior to the Great Fire of 1878, three US presidents stayed at Congress Hall: James Buchanan, Franklin Pierce, and Ulysses S. Grant. Grant came four different seasons in the 1870s, but only for short visits. In the late 20th century, Congress Hall named a room for him and displayed it to the public. (CMCHGS.)

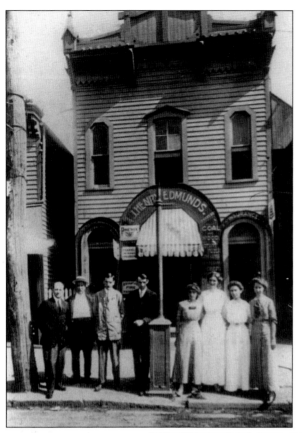

J. Henry Edmunds was very active in Cape May politics, serving as mayor of Cape May City for several years in the late 1800s. Edmunds was also the owner and publisher of Cape May's local newspaper, the *Cape May Wave*. Seen here around 1910, unidentified people stand in front of his real estate and insurance company business on Washington Street. (CMCHGS.)

Probably named for the *Cape May Wave*'s owner, the schooner *J. Henry Edmunds* is seen here around 1910 anchored off the Cape May coastline. She was a pilot boat, delivering or picking up boat pilots who were required to guide steamer and sailing ships up and down the Delaware River between Philadelphia and the mouth of the Delaware Bay. (CMCHGS.)

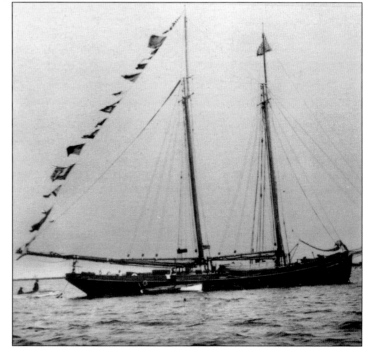

Entomologist Dr. Henry Fox plants a tree along one of the city's streets in memory of Otway Brown in 1948. Brown, an amateur botanist, was the private gardener for the Physick Estate on Washington Street. He coauthored *The Check-list of the Vascular Flora of Cape May County, New Jersey*, which identified 1,150 plants native to the county. (CMCHGS.)

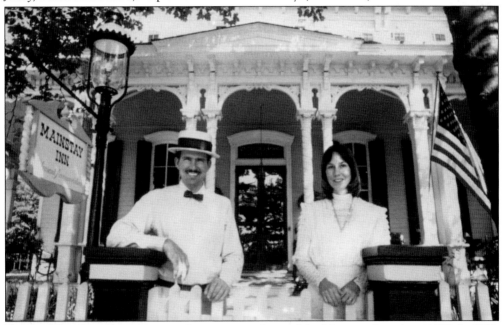

Tom and Sue Carroll pose in period costumes in front of the Mainstay Inn about 1980. In 1977, they bought and restored this spacious Victorian-era mansion on Columbia Avenue to its 1872 grandeur. It was formerly a gambling establishment known as Jackson's Clubhouse. The Carrolls created the first bed-and-breakfast in the city and were leaders in the national B&B movement, setting a standard for the industry. (Tom and Sue Carroll.)

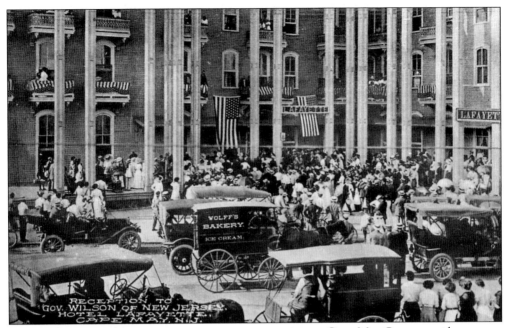

Cape May County residents gathered on August 14, 1911, to hear Gov. Woodrow Wilson address them from a balcony in front of the since-demolished Lafayette Hotel. While visiting the city, he sailed to inspect the fishing banks off the coast, which were the subject of proposed legislation. Wilson stopped at several of the county's shore towns that year and returned in October 1912 while campaigning for the presidency. (DP.)

James "Commodore" Doyle, a 39-inch-tall little person, poses in front of a painting of the steamer *Republic* in 1893. Doyle, dressed in a miniature uniform, claimed to be the smallest sailor afloat and was hired that year to provide entertainment on the steamship's daily trips between Philadelphia and Cape May. He promenaded on the side-wheeler's decks, singing and telling stories of his life as a performer. (CMCHGS.)

104

State senators Charles Sandman (far right) sits with, from left to right, Bernard Berk, Mayor Frank Gauvry, and Arthur Blomvest at a city council meeting in the 1960s. Sandman advanced a number of projects that enhanced city development and tourism, including the Cape May–Lewes ferry, marina development, and the high-level bridge into the city over the Cape May Canal, dubbed the "Sandman Skyway." (CMCHGS.)

Rev. Carl McIntire stands between two unidentified men around 1965 in front of the former Hotel Cape May, which McIntire bought and renamed the Christian Admiral. The hotel provided rooms for his followers as well as conference facilities for weeklong religious seminars that McIntire sponsored. As he expanded his activities, McIntire moved several historic buildings to the hotel site, saving them from demolition. (CMCHGS.)

Levin Handy, nephew and former apprentice of his uncle, noted Civil War photographer Mathew Brady, partnered with Haddonfield, New Jersey, photographer Samuel Chester around 1880. Handy probably took the photograph of Chester (left) about this time. (LOC.)

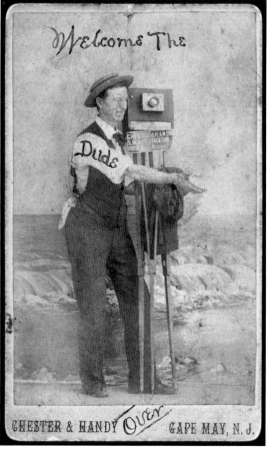

By 1882, they were operating a studio in Cape May, advertised on the postcard (right), which was located at the south end of the Stockton Hotel bathhouses on Beach Avenue. They partnered with Brady in 1883 to market his images from the Civil War, maintaining studios in Cape May and Washington, DC. Chester left the partnership in 1884 and remained in New Jersey. Handy established a studio at his home in Washington, DC. The Cape May studio no longer stands. (LOC.)

Nine

STREETSCAPES

Ocean Ave. from Beach, Cape May, N. J.

A. W. Hand, Cape May, N. J. *1906*

The corner of Ocean and Beach Avenues was a busy one, as seen in this 1906 postcard. Several hotels lined both sides of Ocean Avenue, including the Colonial (right), the Star Villa, and the Fairmont. A photography booth (far right) offered tintypes and was positioned at the west corner of the Stockton bathhouses. (NASW.)

Beach Avenue at its intersection with Decatur Street featured a variety of buildings, as seen here around 1920. The four-story building at the corner, where it still stands, was Denizot's Ocean View House, built shortly after the 1878 fire. The small hotel also featured a bathhouse and a restaurant. Denizot later built the Iron Pier across the street and the Lafayette Hotel next door. (DP.)

Jackson St from the Beach, Cape May, N J.

A. W. Hand, Cape May, N. J.

This early-20th-century view of Jackson Street, looking west, features a Japanese art gallery on the left. Beyond the gallery are the Atlantic Terrace cottages, built in 1892. On the opposite corner is the imposing three-story cottage built by William King after his original house and a group of bathhouses he operated on this site burned down in the 1878 fire. (DP.)

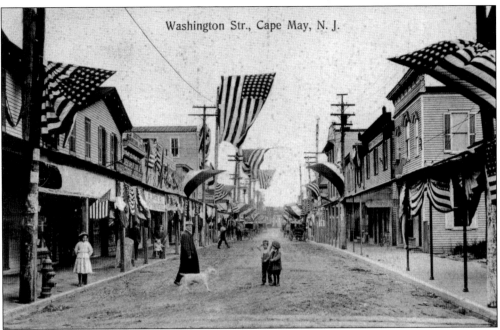

Washington Str., Cape May, N. J.

These nearly identical views of Washington Street, looking east near the corner of Perry Street, show the city's bustling commercial district as it appeared in the early 20th century. Today, this is the western terminus of Washington Street mall near Congress Hall. Although many of the buildings seen here still stand, most have been altered from their original appearance, particularly along the roof line. When the above photograph was taken before 1909, the two-story structure on the left housed a jewelry store. A vacant lot is seen across the street. By the time the below photograph was taken after 1909, a group of stores and the Palace Movie Theatre had been built on the vacant lot. (Both, DP.)

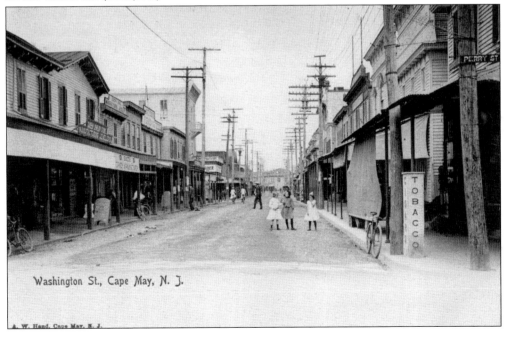

Washington St., Cape May, N. J.

CONGRESS PLACE. CAPE MAY, N. J.

Congress Place, a one-block-long street behind Congress Hall, was a fashionable address in the early 1900s. In this postcard mailed in 1918, the first two houses on the left were built for E.C. Knight and Joseph Evans in the winter of 1881–1882 and are attributed to Philadelphia architect Stephen D. Button. The shorter cottage is the Dr. Henry Hunt House, built about the same time. All three still stand. (DP.)

3068 PANORAMA OF CAPE MAY, N. J. ILL. POST CARD CO., N. Y

This c. 1905 photograph looks south on South Lafayette Street from the corner of Perry Street. At the far end of the street are Grant Street and the Pennsylvania Railroad's summer station, built in 1876. In the distance to the right are the summer cottages built on the site of the former Mount Vernon Hotel and located south of the borough of West Cape May. (DP.)

110

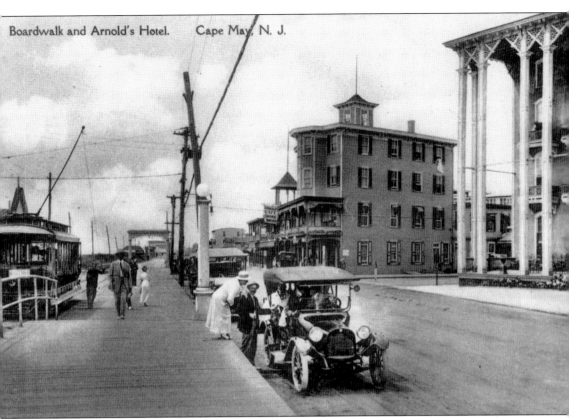

Boardwalk and Arnold's Hotel. Cape May, N. J.

This photograph of Beach Avenue and the boardwalk, taken around 1914, shows a portion of the Lafayette Hotel and its columns (right). On the opposite corner is Arnold's Café, which featured "Shore Dinners." Arnold's Café, originally known as Denizot's Ocean View house, was built in 1879 by Victor Denizot after the 1878 fire ravaged this block. A small hotel, the Ocean View offered a restaurant on the ground floor and bathhouses in the rear of the property. Denizot was a successful entrepreneur who also built the Lafayette Hotel in 1882 and the highly popular Iron Pier on the other side of the boardwalk in 1884. The shops marking the Iron Pier's entrance are seen to the far left. The motorman next to the Cape May, Delaware Bay & Sewell's Point Railroad trolley is turning the trolley pole so it faces the right direction for the next trip. (HGM.)

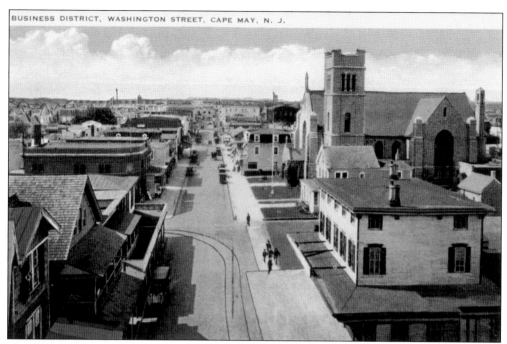

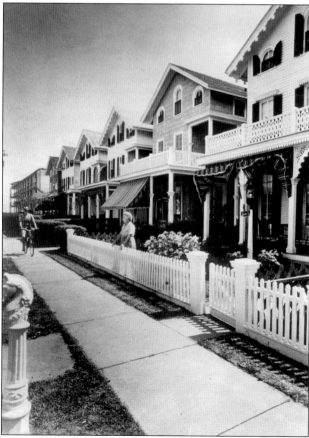

This c. 1930 aerial photograph of Washington Street looks west from the Reading Railroad station at the bottom right. St. Mary's Church, built in 1911, dominates the landscape on the right side of the street. Opposite the church is the two-story New Jersey Trust & Safe Deposit building, constructed of brick in 1895 and now used as a store. (CMCHGS.)

These nearly identical gable-front cottages, seen here in the mid-20th century, were built on the west side of Gurney Street in 1872. They faced the Stockton Hotel and were known collectively as "Stockton Place." Designed by Philadelphia architect Stephen D. Button, the houses had simple exteriors lavished with porches and an abundance of wooden trim. All still stand today. (CMCHGS.)

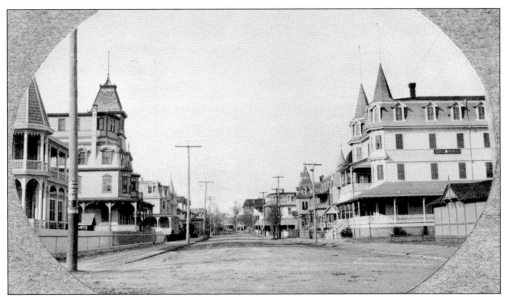

Taken from Beach Avenue, this photograph looks north up Ocean Street around 1900. In the foreground, two popular hotels face each other: Star Villa, built in 1885 (left), and the Colonial (right), built in 1894. Beyond the hotels are private cottages, most of which still stand. Although the city has electric power, the streets are still unpaved. (CMCHGS.)

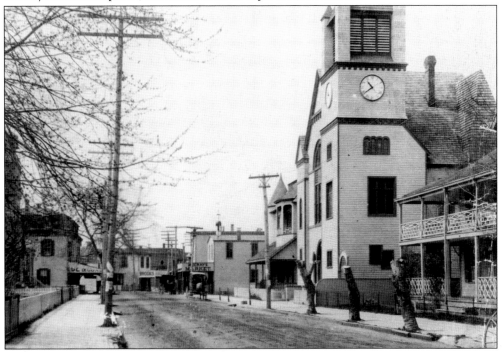

This c. 1900 photograph of Washington Street, looking west toward the heart of the business district, features the recently remodeled Methodist church (right). In 1892, the congregation hired local builder Enos Williams to design a new facade, and its bell/clock tower became a focal point of the streetscape. The church still stands, but Williams's distinctive addition was removed in the 1970s. (CMCHGS.)

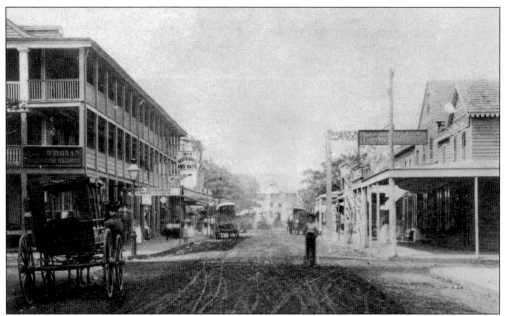

Taken in the late 1800s, this photograph looks west down Washington Street from the corner of Decatur Street. Congress Hall stands at the far end of the street. This view shows the city's busy commercial district. The stores lining both sides of the street represent those of diamond cutter Henry Alexander, milliner Mrs. O'Bryan, druggists Kennedy and son, and jeweler C.M. Leeds, among others. (CMCHGS.)

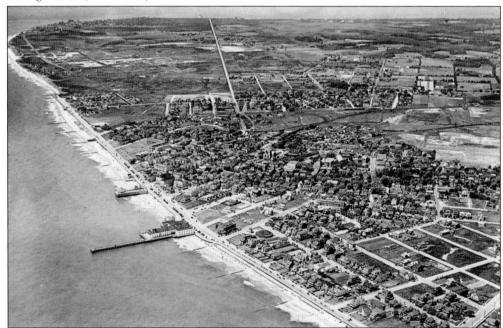

This aerial photograph, looking west, shows Cape May City and environs in 1932. Convention Hall and its pier stand opposite the site of the former Stockton Hotel, demolished in 1910 and upon which only a few new buildings had been erected. The road to Steamboat Landing, now Sunset Boulevard, makes a straight line from the city to the shore of the Delaware Bay. (CMCHGS.)

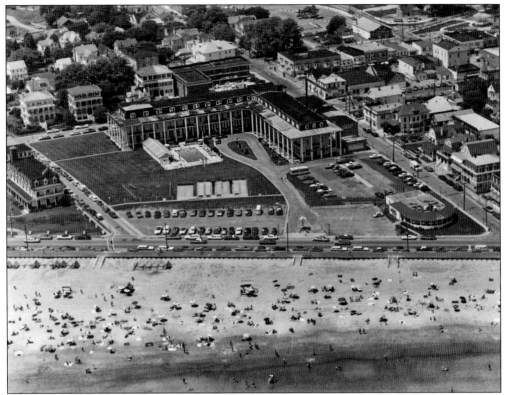

Congress Hall had made several changes to its facility by the 1960s, as vacationers increasingly arrived by automobile rather than by train. Its expansive front lawn, which had been dotted with bathhouses, a billiards pavilion, and a photographer's booth in the 1890s, was now given over to a semicircular cocktail lounge, a swimming pool just steps away from hotel rooms, and ample off-street parking. (CMCHGS.)

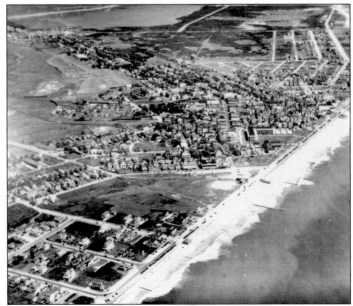

Looking northeast over Cape May, this c. 1940 aerial photograph shows, in the left foreground, several streets with scattered summer cottages on the site of the former Mount Vernon Hotel. They adjoin, to the east, the large, vacant site of the former Grant Street summer station, torn down after 1933. Both areas have been wholly redeveloped. (CMCHGS.)

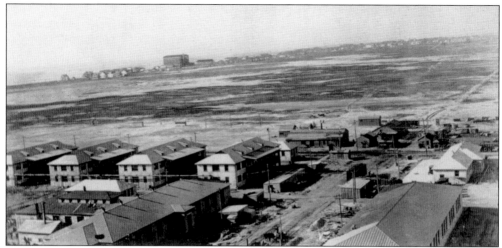

The US Navy established Section Base Nine in 1917 on several hundred acres at Sewell's Point. Today, this site is the US Coast Guard Training Center. In the foreground of this c. 1920 aerial photograph are the base's barracks and support buildings. The tall Hotel Cape May, completed in 1908, dominates the horizon in the distance. (GM.)

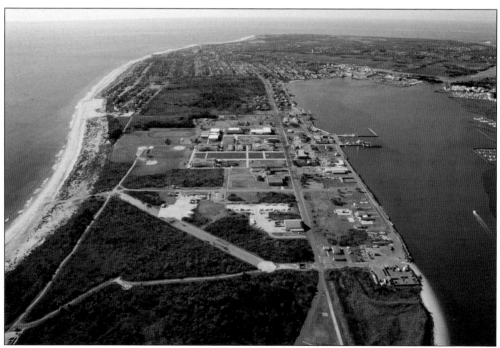

This 2011 photograph shows the expansive facility of the US Coast Guard Training Center, situated between the Cape May harbor and the Atlantic Ocean. The Hotel Cape May (later known as the Christian Admiral) is no longer part of the landscape; it was torn down in 1996. The Cape May canal and the high bridge going over it are seen at upper right. (Richard Fedeke.)

Ten

COMMERCIAL, RELIGIOUS, AND GOVERNMENT BUILDINGS

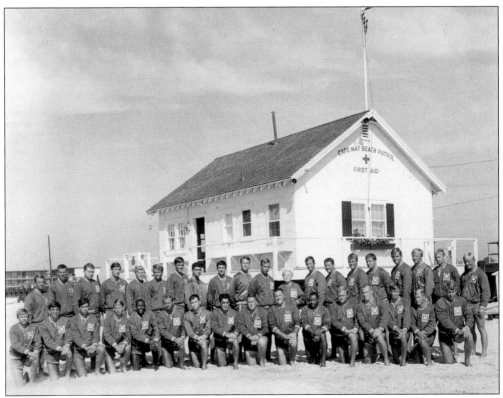

By the mid-1800s, the city's larger hotels hired crews to man surfboats during the bathing hours. Rivalries developed, and lifeboat races were held to entertain summer guests. In 1911, the Cape May Beach Patrol was organized, and professional lifeguards were hired to protect bathers along the resort's two-and-one-half miles of beach. A beach patrol is seen here in the 1960s. (CMCHGS.)

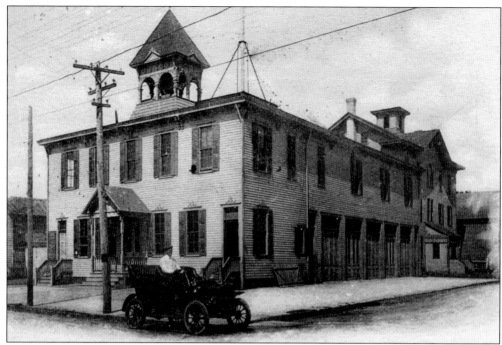

Typical of those built around the turn of the last century, Cape May's city hall combined municipal offices with the fire department. The five tall doors on the side provide access to the firefighting apparatus. Erected in 1899, this building stood at the corner of Franklin and Washington Streets, replacing an earlier city hall at the same site. The 1899 structure was torn down in 1970, and today the site is occupied by the fire museum. (DP.)

Cape May erected this new high school in 1917 on Washington Street, just east of the Methodist church. In order for the school to be built, a house standing on the site was moved to 815 Jefferson Street, behind the Washington Inn, where it still stands. The school became city hall in 1961, a use that continues today. The first high school stood near the site of today's Acme supermarket. (CMCHGS.)

By 1909, this three-story brick building with a masonry facade was serving as Cape May's post office. The structure, still standing at the corner of Ocean Street and Carpenter Alley, is a local eatery. Historic maps show that the city's post office moved often and, in the 1890s, stood on the 300 block of Washington Street, not far from Congress Hall. (DP.)

Dr. James Kennedy opened the city's first drugstore in 1843. About 1870, he and his son, Henry, built the United States Pharmacy at the corner of Washington and Decatur Streets. It was named for the United States Hotel, which stood at this location but burned down in 1869. This drawing shows the Kennedy establishment as it looked around 1878. (CMCHGS.)

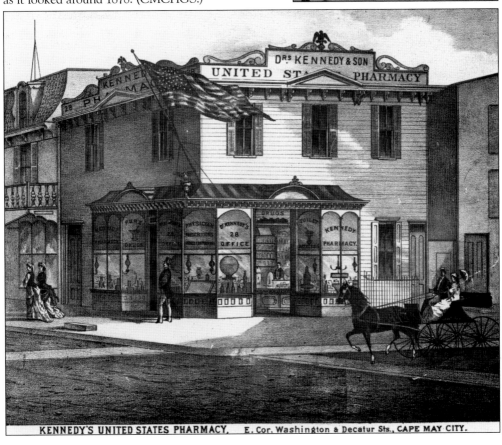

KENNEDY'S UNITED STATES PHARMACY, E. Cor. Washington & Decatur Sts., CAPE MAY CITY.

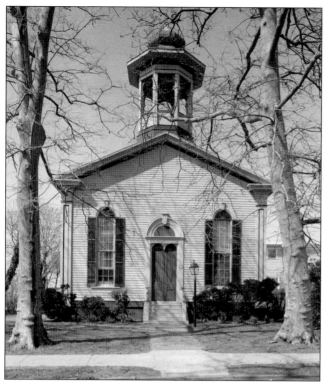

Cape Island Presbyterian Church, seen here in 1977, was built in 1853. It still stands on Lafayette Street, west of Bank Street, and now serves as a venue for local theater productions, classes, and other community and arts group activities. After the congregation moved to a new building at Hughes and Decatur Streets in 1898, the building served as an Episcopalian church and was briefly a visitor welcome center. (LOC.)

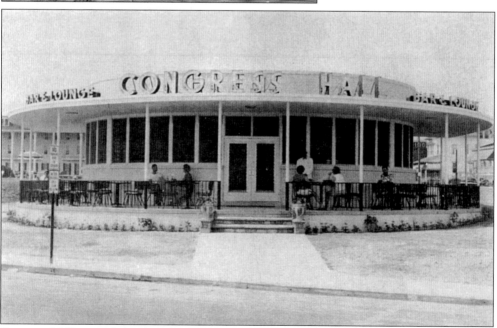

Congress Hall opened this futuristic-looking semicircular bar and lounge in the mid-1900s. At the time, nearby Wildwood was building hotels with space-age details; Cape May was anxious to look similarly modern. The structure still stands, greatly expanded but somewhat recognizable, on the hotel's front lawn at the corner of Beach Avenue and Perry Street. It is a popular pancake house. (DP.)

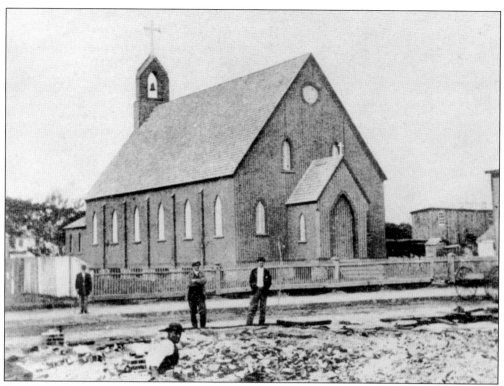

Cape May County was dominated by Methodism, but it also had Baptist and Presbyterian followers in the Colonial and early American eras. Roman Catholics built their first church in the county on Cape Island in 1848, at the location of the present church on Washington Street near the Ocean Street intersection. Known as St. Mary's and later as "Star of the Sea," it has the distinction of being the first church of that faith to be built along the Jersey shore. Services were held every Sunday during the summer months and once a month the rest of the year in this simple gable-fronted wood building.

The present grandiose stone structure, seen here about 1915, replaced the earlier one in 1911. It was designed by architect George Lovatt, who was responsible for many important Catholic churches in Philadelphia. (Both, CMCHGS.)

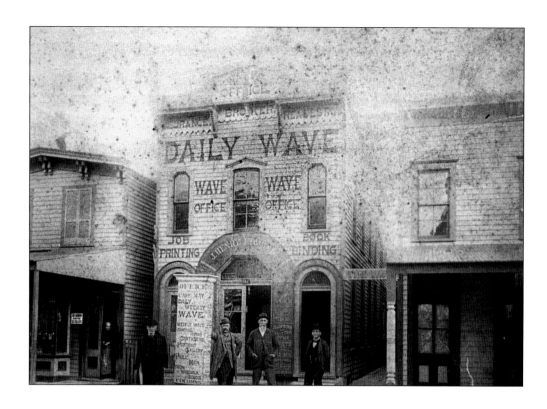

Cape May City's first newspaper, and the oldest newspaper in the county, was the *Cape May Ocean Wave*, which began publication in 1854 as a weekly paper. In 1876, it became the *Cape May Wave*, publishing a daily edition in the summer called the *Cape May Daily Wave* until 1904. J. Henry Edmunds, a local insurance agent and real estate broker, purchased the paper in 1886 and housed its offices in his commercial building on Washington Street, seen above about 1900. Edmunds used the paper as the voice of the local Democratic Party and as a way to promote his many real estate development schemes in both Cape May City and on the lower end of the Jersey cape in the late 1800s. Shown below is a 1901 receipt for a year's subscription, costing 50¢. (Both, CMCHGS.)

Grocer Joseph Brooks operated Central Market at the corner of Washington and Ocean Streets around the turn of the century. As seen in this c. 1900 photograph, he had a fleet of horse-drawn wagons ready to deliver orders. His large store, which no longer stands, was located nearly opposite the Washington Street passenger station of the Reading Railroad. (CMCHGS.)

In the 1920s and 1930s, Laura Brown operated this millinery and dry goods store at 417 Washington Street. Her husband, William, was a plumber, and they rented a house on Mansion Street before moving here sometime before 1920. Note the carved Indian plaque mounted by the door to advertise the cigar store adjacent to Brown's shop. (CMCHGS.)

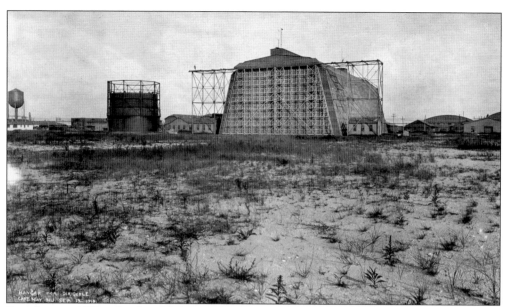

Seen here in 1919 is the dirigible hangar built on US Navy Section Base Nine, now the site of the US Coast Guard Training Center. The hangar was erected in 1918 to house lighter-than-air craft that debuted as weapons in World War I. Doubled in size in the spring of 1920, the facility later became obsolete and fell into disrepair. It was demolished in July 1941. (CMCHGS.)

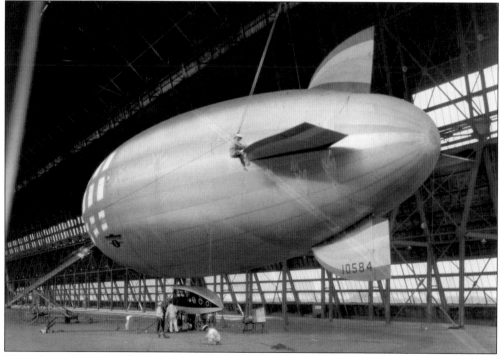

Capt. Anton Heinen, a German dirigible expert, developed a 100-foot-long "baby blimp" that he hoped to market as a way for families to travel by air safely and efficiently. But its $10,000 cost and the fact that it needed a skilled pilot for takeoffs and landings made it impractical. It is seen here in 1930 before taking a test flight from Cape May to Atlantic City with three passengers. (CMCHGS.)

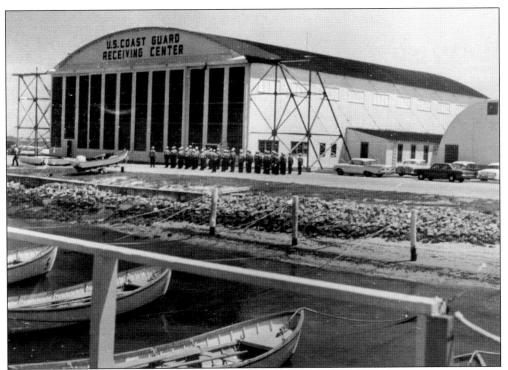

A group of Coast Guardsmen, likely recruits, stands in formation outside of the large hangar that was built when the site was a US Navy air station during World War II. The US Coast Guard took over the base in 1946 and in 1948 established a training center here, handling up to 200 recruits monthly. (NASW.)

This postcard from the mid-1960s shows US Coast Guard recruits lined up around the World War II–era boathouse. The two boats tied to the dock are 30-footers, one made of fiberglass and the other of steel. The 26-foot motorboat in the foreground appears to have been a "captain's gig"—a wooden cruiser found on 327-foot cutters that was reserved for the captain as his launch. (NASW.)

BIBLIOGRAPHY

Alexander, Robert. *Ho! For Cape Island!* Cape May, NJ: Robert Alexander, 1956.

Beesley, Maurice. "Sketch of the Early History of the County of Cape May," in George H. Cook, *Geology of the County of Cape May, State of New Jersey*. Trenton, NJ: Office of the True American, 1857.

Beitel, Herb, and Vance Enck. *Cape May County: A Pictorial History*. Norfolk, VA: The Donning Company, 1988.

Dorwart, Jeffery M. *Cape May County, New Jersey: The Making of an American Resort Community*. New Brunswick, NJ: Rutgers University Press, 1992.

Miller, Ben. *The First Resort: Fun, Sun, Fire and War in Cape May, America's Original Seaside Town*. Cape May, NJ: Exit Zero Publishing, 2010.

Salvini, Emil R. *The Summer City by the Sea: Cape May, New Jersey—An Illustrated History*. Belleville, NJ: Wheal-Grace Publications, 1995.

Stevens, Lewis Townsend. *The History of Cape May County, New Jersey*. Cape May, NJ: Star of the Cape Publishing Co., 1897.

Thomas, George E., and Carl E. Doebley. *Cape May: Queen of the Seaside Resorts*. Privately printed: The Knossus Project and Mid-Atlantic Center for the Arts, 1998.

About the Organization

Naval Air Station Wildwood Foundation is a not-for-profit organization whose mission is to restore Hangar No. 1 at the Cape May Airport, Cape May County, New Jersey, and to create an aviation museum honoring the 42 Navy airmen who died while training at the station during World War II.

In June 1997, NAS Wildwood Foundation purchased Hangar No. 1 at the Cape May Airport. The 92,000-square-foot, all-wooden structure was in a state of disrepair and required extensive renovation. Under the stewardship of NASW Foundation, the hangar was listed in the New Jersey and National Registers of Historic Places and is considered nationally significant for the role it played in World War II.

NAS Wildwood Aviation Museum now boasts over 26 aircraft displays as well as exhibits of military memorabilia, engines, photographs, and more. Additionally, the Franklin Institute of Philadelphia donated a wealth of interactive exhibits that allow visitors to discover the science of flight. The museum features a library, food vending area, and a recently expanded gift shop.

In its role as a community resource, NAS Wildwood Aviation Museum hosts activities including fly-ins, aviation festivals, big-band concerts, swing dances, veterans' ceremonies, historical lectures, school field trips, and senior tours. The museum is open daily during the spring, summer, and fall; call for winter hours.

You are invited to become a member of NAS Wildwood Aviation Museum. Your membership supports the mission of the foundation, which is a tax-exempt 501(c)(3) organization. Membership entitles one to the following: free admission to NAS Wildwood Aviation Museum; 10 percent discount in the gift shop; advance invitations to special events and museum functions; reduced admission to special events; and issues of the aviation museum quarterly newsletter *The Osprey*. Please help us give the past a future and become an NASW member! Visit our website, www.usnasw.org.

Naval Air Station Wildwood Aviation Museum
500 Forrestal Rd.
Cape May Airport, NJ 08242
Telephone (609) 886-8787
Fax (609) 886-1942

Discover Thousands of Local History Books
Featuring Millions of Vintage Images

Arcadia Publishing, the leading local history publisher in the United States, is committed to making history accessible and meaningful through publishing books that celebrate and preserve the heritage of America's people and places.

Find more books like this at
www.arcadiapublishing.com

Search for your hometown history, your old stomping grounds, and even your favorite sports team.